SAMURAI GIRL
by Julie

Published by DRAGO

VIA ADDA, 87 – 00197 ROME [ITALY]
INFO@DRAGOLAB.IT – WWW.DRAGOLAB.IT
PH. +39 06 45439018 – FAX: +39 06 45439159

Project by
PAULO VON VACANO & FRANCESCO FONDI

Editor
BIN VON

Graphic design
NICOLA SCAVALLI VECCIA [DRAGOLAB]

Digital immaging
STUDIO PREVIEW *by* **DONNA ARCAMA**

Printing
ARTI GRAFICHE (POMEZIA ITALY)

Copyright ©2006
DRAGO ARTS & COMMUNICATION s.r.l.

Isbn: **88-88493-27-1**

For more information please check:
www.dragolab.it
www.dragobooks.com

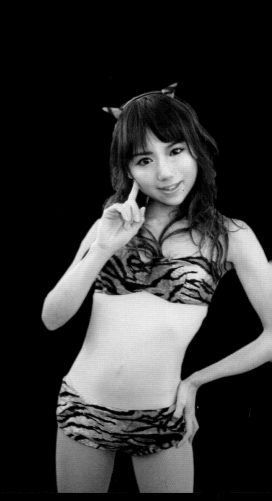

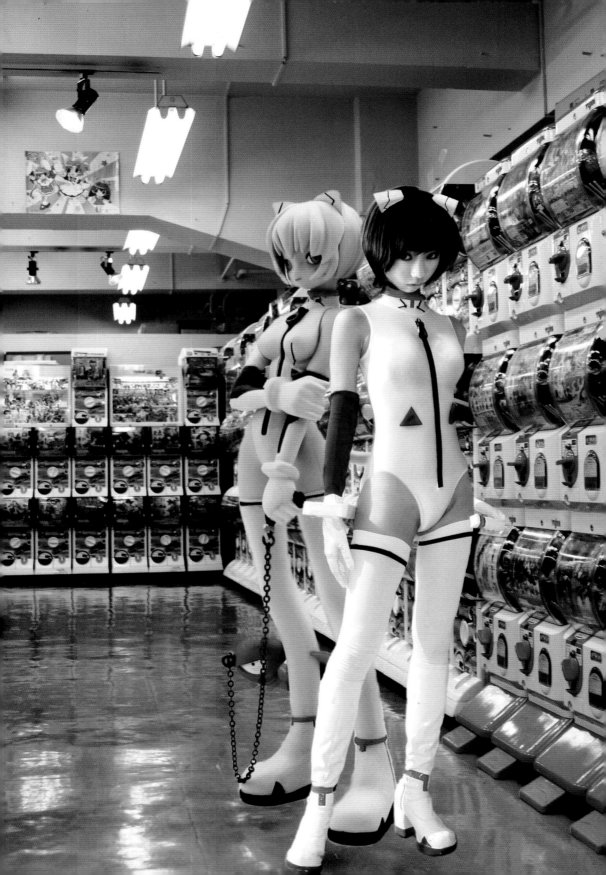

SPIRITUALITY
& TECHNOLOGY
FOR THE MOE
CONSCIOUSNESS

SAMURAI GIRL
YAMATO NADESHIKO MOE GENERATOR

SAMURAI GIRL

YAMATO NADESHIKO MOE GENERATOR

REALITY AS IT'S HAPPENING IN THE SAMURAI WONDERLAND

Julie is a "manga photographer" who enjoys tracing out psychogeographic maps of the imagination of a generation of young Japanese whose lives are absorbed in video games, cartoons and the Wired. Her creative activity ranges from several contributions for the production of video games (she is the author of the preparatory photos to the cult game "Killer 7") to the production of promos for MTV Japan. Julie is a Samurai Girl who turns into Alice (100% MOE). She shows us the White Rabbit in a manga version and allows us to see him situated in places we would have never imagined…godzilla girls as tall as a building, garage kit (vinyl statuettes) which seem to be real, DJs in cosplay who play Toypop music and toys that turn into something else…a lysergic walk along the streets and the monitors of the "Electric City" where reality becomes "hyper" and soon (or later?) we'll start to ask ourselves: "Which is which?". Ittekimasu!!

FRANCESCO FONDI - editor of "Otaku" magazines

As much as I know Julie is a girl, a photographer, a singer, a freelancer, a designer and a cosplayer. In today's Japan it is difficult for young people to pick out the right way to achieve their goals and this is due to the problems ensuing from the country's social and mental situation, but Julie is a person who knows many "ways" and has as many "objectives". That's not all: besides having found her way, she also owns the firmness and the willpower to achieve her goals through an astonishing commitment and passion. So, maybe, it was thanks to the natural course of the events that she managed to publish her book of photographs. I thank luck that gave me the possibility to assist at the debut of Julie and of her talent and I seize the opportunity to wish her all the best.

YOSHIDA AGE SOFT - video game producer

私が知る限りJULIEという少女は、カメラマンであり、歌手であり、ライターであり、イラストレーターであり、コスプレイヤーであった。社会環境や精神的な問題から、若者が自分のやりたい事や進むべき道を見つける事が困難になりつつある今の日本で、彼女は抱えきれない程の「やりたい事」と「道」を持っていたのだ。そして、それらを見つける以上に困難な「継続」や「努力」という難業に彼女は立ち向かい続けた事は想像に難くない。彼女が己の信念を貫き、こうして写真集を出版する段階まで辿り着いたのは、ごく自然な成り行きなのだろう。JULIEという才能のデビューに立ち会う機会をいただいた幸運に感謝し、彼女の長い旅の始まりに祝福を送りたい。

YOSHIDA AGE SOFT - video game producer

Best wishes for the publication of the book of photographs! I was looking forward to finding out what kind of pictures Juliechan might had created, with her mysterious appeal typical of those who are so nice (kawaii) but that at the same time like the "dark". Keep on going in this direction, continue making works that only a girl can conceive, supported by a strong commitment and bursting with passion. I will always support you and anytime you'll need me I will always be there for you!

KURUMI MORISHITA - AV Idol

When I first saw Julie she embodied a little devil. Even though, to date, I have met a great variety of people, nobody appeared to me so graceful as Julie. Really. That such a "cute" girl takes such "cute" photos, means that God gave her two talents. It must be this way. The book of gracious Julie will offer you a high level sweetness, rendered very very sweet. And me myself...I get lost in this sweetness. Best wishes for you debut!

TEI "Furi Furi Company" - designer

写真作品集、発売おめでとう!とっても可愛いのにダークな物も好みな、
不思議な魅力のジュリちゃんがどんな作品集作るのか、凄い楽しみでしたよー★これからも死力を尽くして、情熱溢れる、女の子にしか出来ない仕事してって下されな!あたしで良かったらいつでも協力します!

KURUMI MORISHITA - AV Idol

JULIEさんがオレの目の前に現れたとき、彼女は小悪魔の格好をして現れた。いろんな人とこれまで出会ったけど彼女ほどキュートに現れたひとは今だかつていないよ。マジで。そんなキュートな彼女がこれまたキュートな写真を撮っちゃうのだから、神様は二物を与えちゃったんだね。きっと。この作品集はそんなキュートなJULIEさんを圧縮してとてもとても甘くした、最高級のスイートをアナタにプレゼントしてくれるだろう。
もちろんオレはスイートさにヤラレっぱなしです☆出版オメデトウ!

TEI "Furi Furi Company" - designer

Dreamed by Julie

SAMURAI GIRL

YAMATO NADESHIKO MOE GENERATOR

"it's going to be sold out for sure! isn't it?..."

ANI "Nendo Graphix" - designer

...こんなの、売れるに決まってるじゃん! ずるい...

ANI "Nendo Graphix" - designer

Quando l'ho incontrata dopo un anno era diventata una meravigliosa donna che emanava una qualche fragranza di maturità. E pensare che quando ci siamo incontrati era solo una ragazzina.

«Mi piacerebbe fotografare un nudo di ragazza visto dagli occhi di una donna»

Questa proposta arrivò nell'estate dell'anno scorso. Ovviamente per me si trattava della prima esperienza. Procedendo a tentoni, era un'opera di collaborazione abbandonata al caso. Una sensazione così piacevole! Non pensavo potesse essere così divertente! A lavoro compiuto, senza sapere perchè, insieme ridendo alzammo le braccia e urlammo «Urrà!!!»

È passato un anno da allora... La sua opera speziata è senza dubbio una sweet cake unica al mondo. È un sapore dolce ma pericoloso che procura dipendenza. Tokyo, Akiba, giochi, anime, cosplay. Godetevi questo mondo dolce e meraviglioso catturato con i suoi occhi.

YUKARI - designer

年ぶりに会った彼女はどこか大人の臭いを漂わせる素敵な女性へと変化していた。
初めて会った時はまだ少女だったのに...
「女性の視線から見た、女の子のヌードを撮りたいと思うんですよ」
そんな話しをされた昨年の夏。もちろん私にとっては初めての経験である。全て手探り、出たとこ勝負の共同作品。もの凄い快感!こんなに楽しいなんて! 撮影終了と同時になぜか二人で笑いながらバンザイをした
それから1年...彼女がスパイスを加えて出来上がった作品はまさに極上の sweet cake
甘くて癖になるキケンな味である東京・秋葉・ゲーム・アニメ・コスプレ
彼女の目で捉えた甘い不思議な世界を味わってみてください

YUKARI - designer

One could almost talk about realism. A neorealistic exaggeration. In the end, the magical Tokyo that Julie photographs, where the imagined, everyday objects, and people continuously intertwine, is extremely realistic. Julie manages to profoundly immortalize an aspect of Japanese culture in all it's richness, folly, and abstractions
JAIME D'ALESSANDRO - Journalist and videogame's writer

We are living the second pop revolution in the first era of globalization. Sein oder nicht Sein. Hello Kitty meets Cat Woman. Ottaku Ambassadress, Ninja Lady, Street Heidi, SAMURAI GIRL is the Moe radar of a nü Japanese undergrünz that will influenza the Global Zeitgeist. The sun is raising in the East meanwhile monotheistik War & Drug-Zeloten are clashing into dawn.
The "Samurai" girls in Julie's photography and graphics capture the contemporary aesthetic for real-life Barbie dolls, Fallen Angels, Godzilla school girls, cosmic superstars, video game superheroes, super sexy pop idols, and Lolita geishas. It alliages Japanese youth fashion fantasy with radical trends & club culture chic. The beautifool dekadenz of Japanese Civilization creates a neue generation of SAMURAI GIRLS® which will rock the nation in a Kawaii Tsunami. Unz - Unz versus Agnüs Dei.
BIN VON - Editor

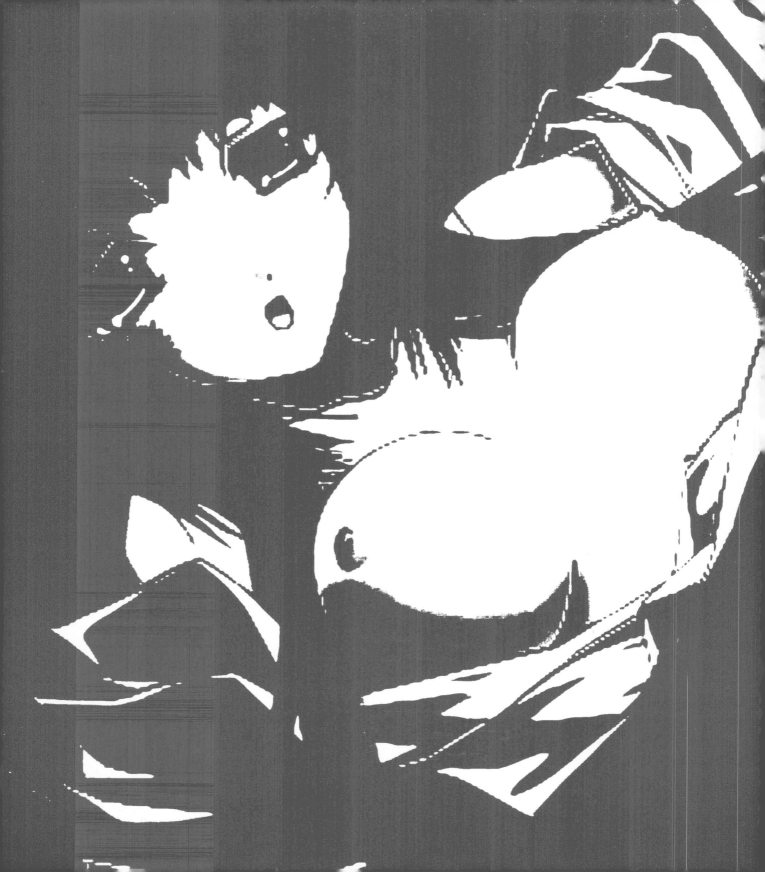

ヌウ

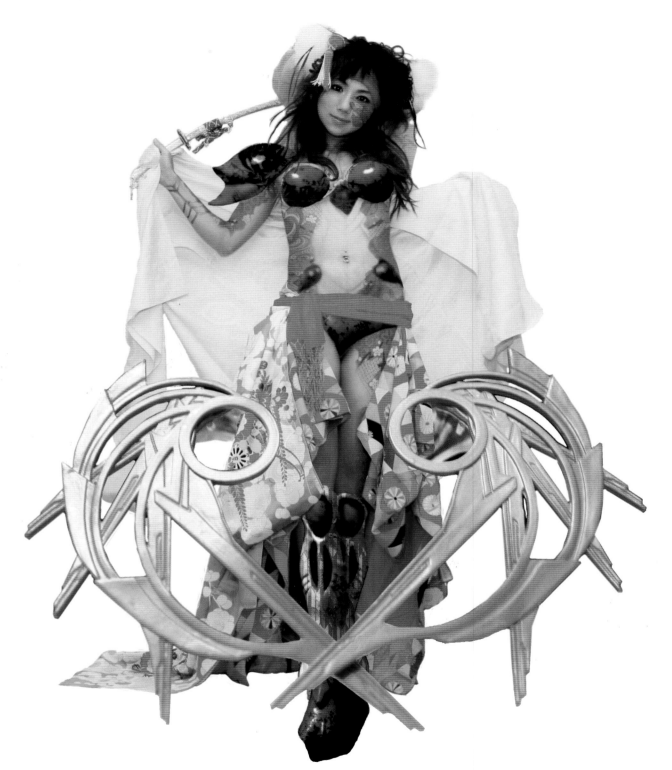

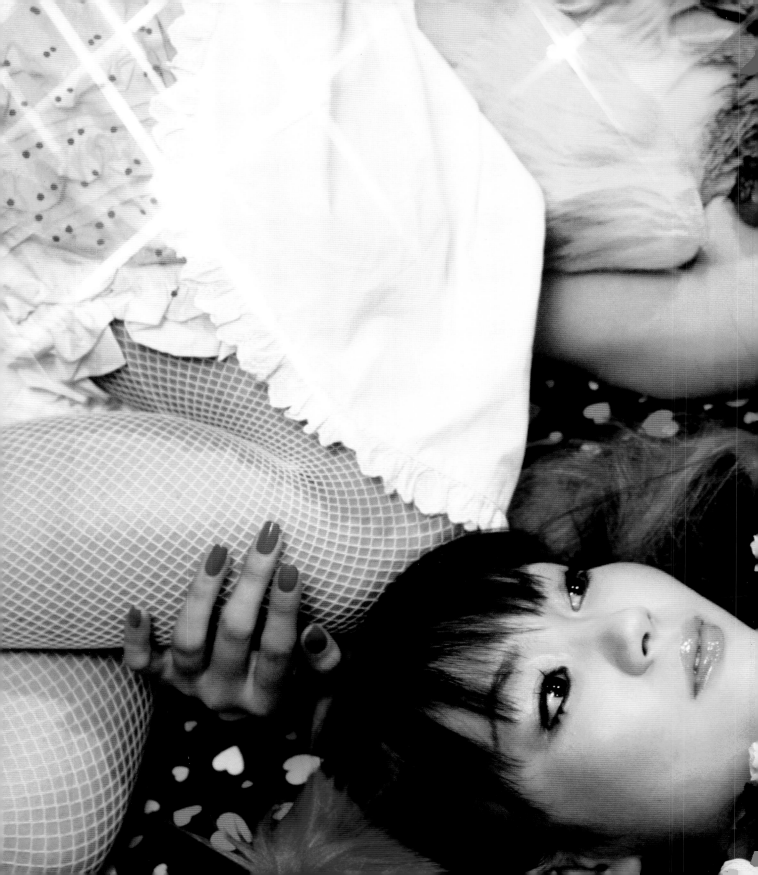

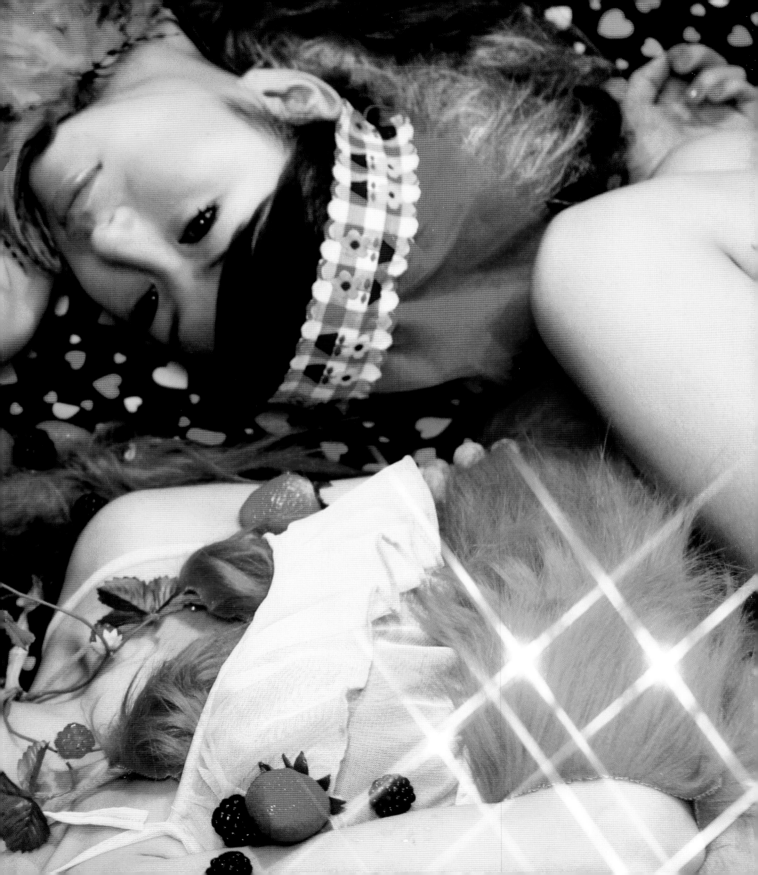

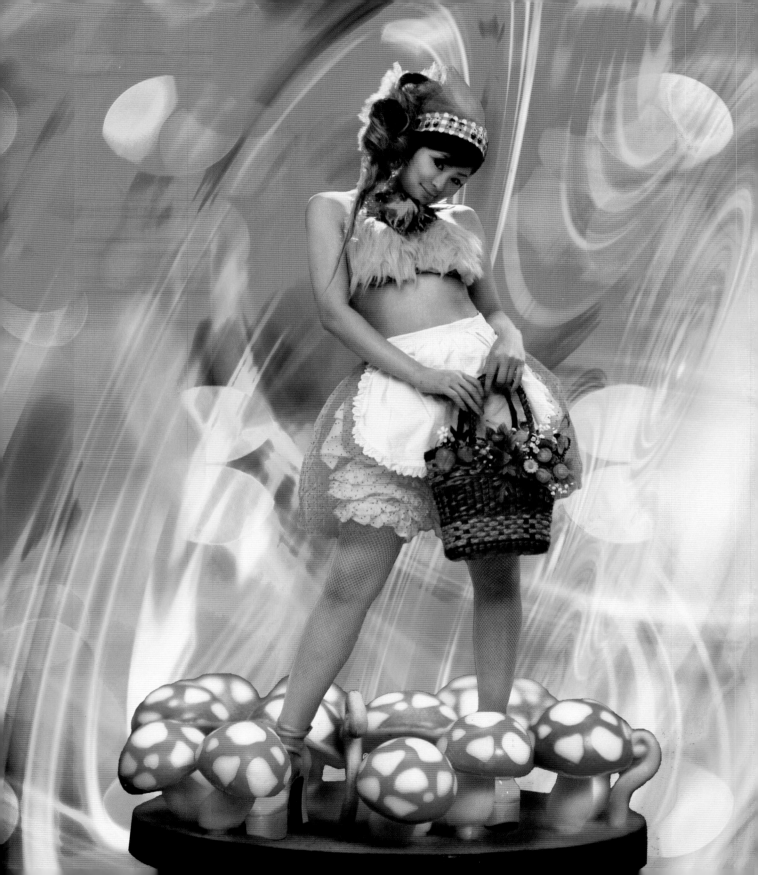

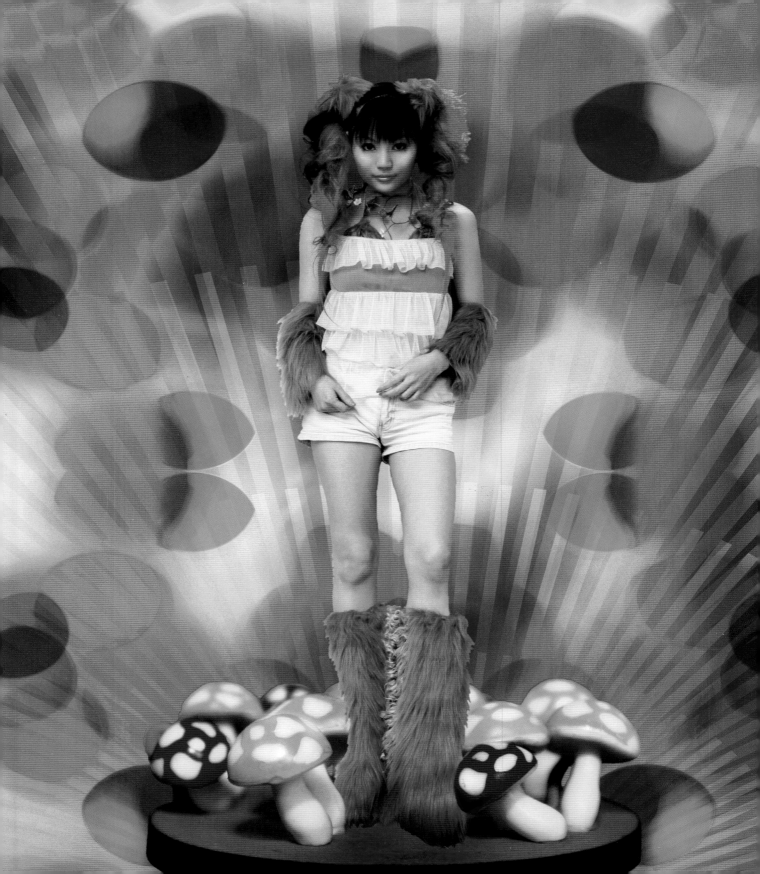

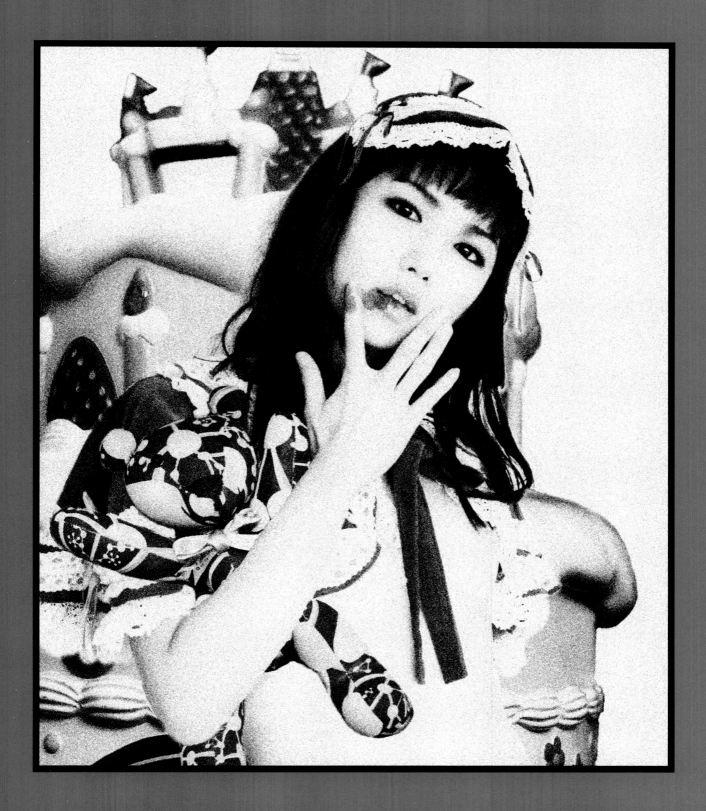

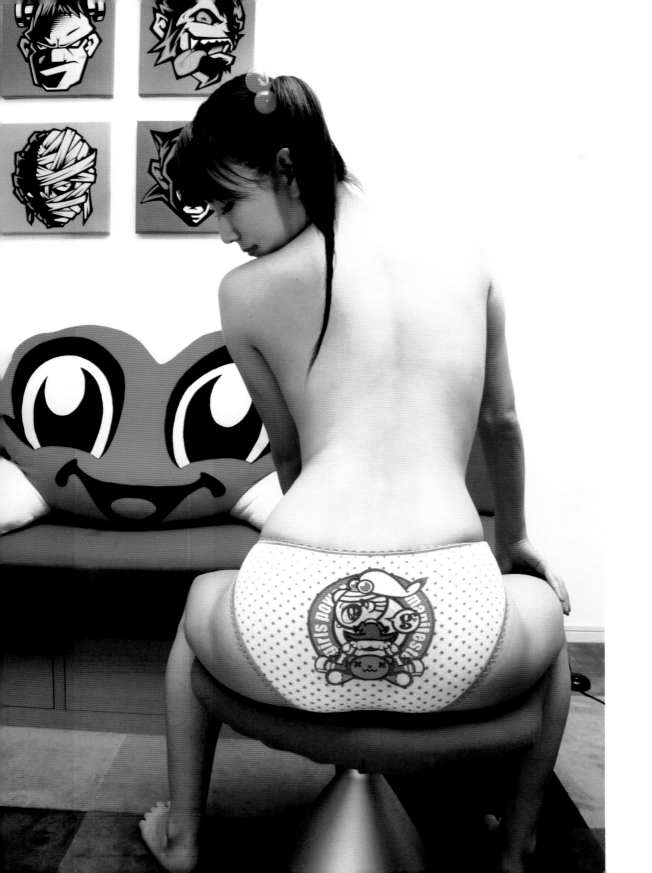

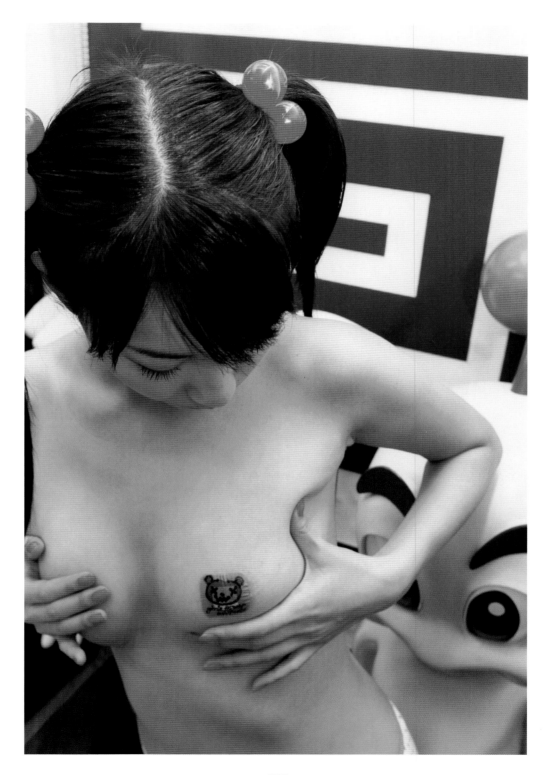

フウ

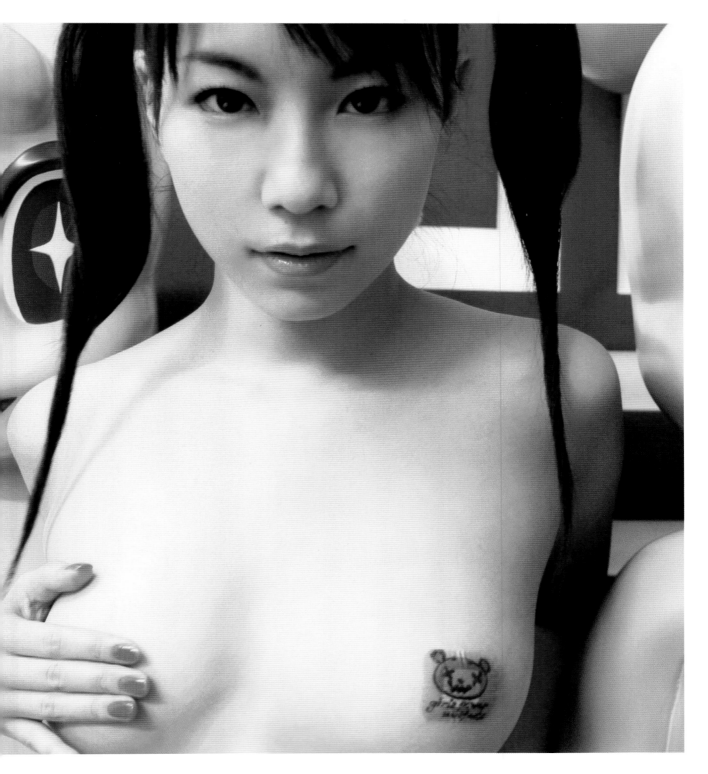

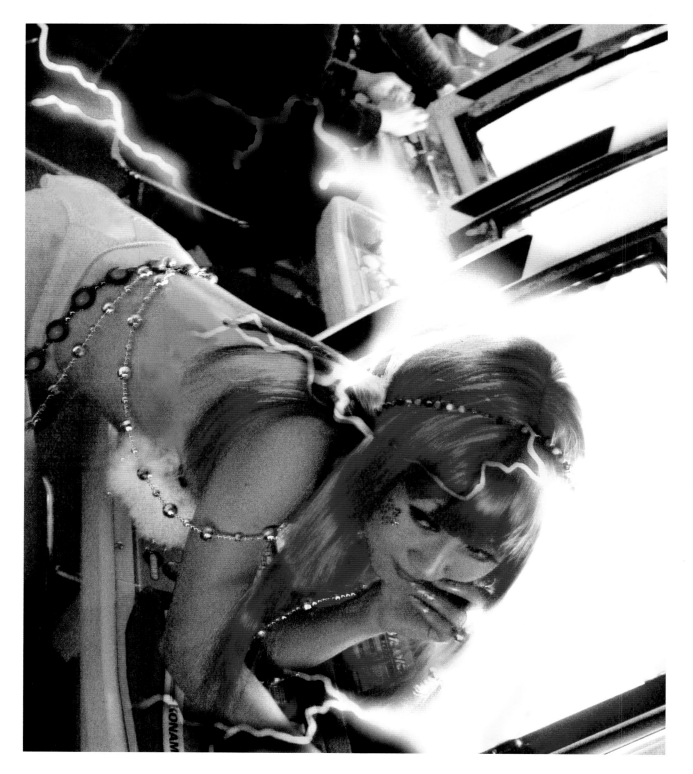

フォ

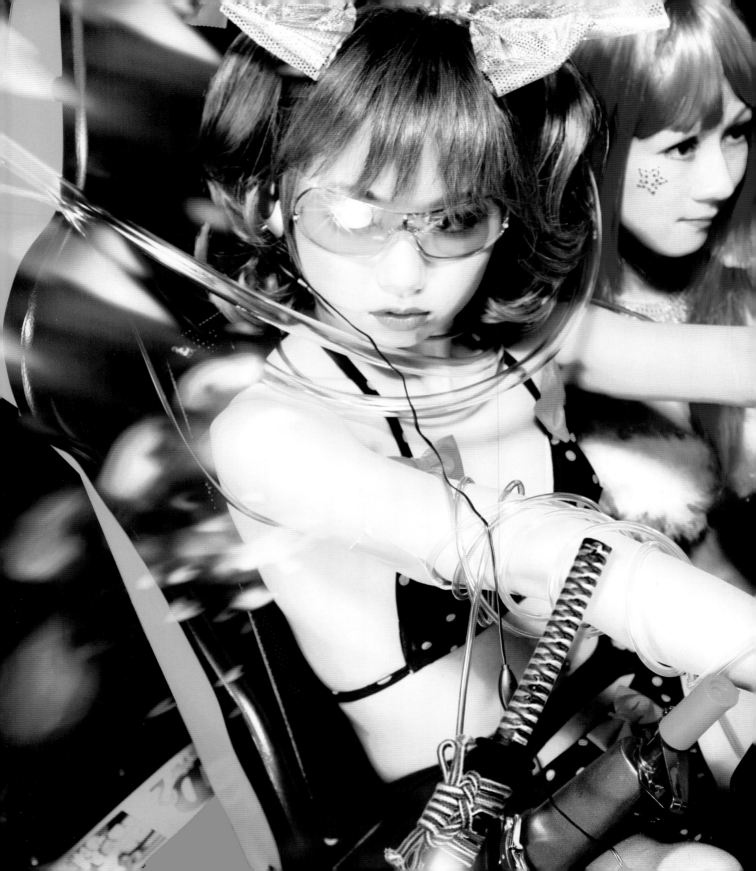

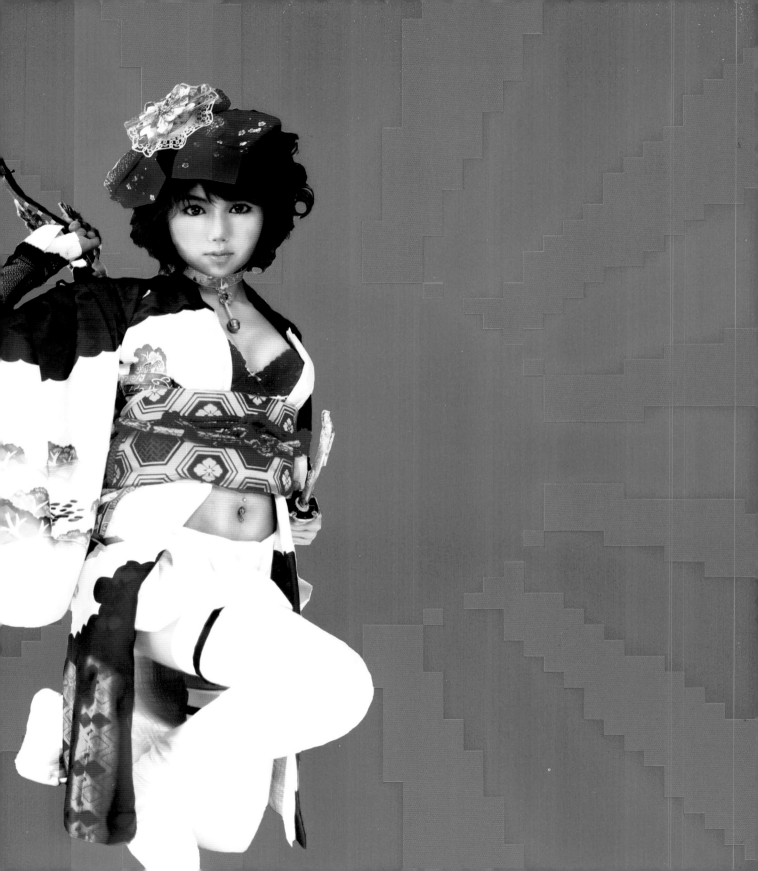

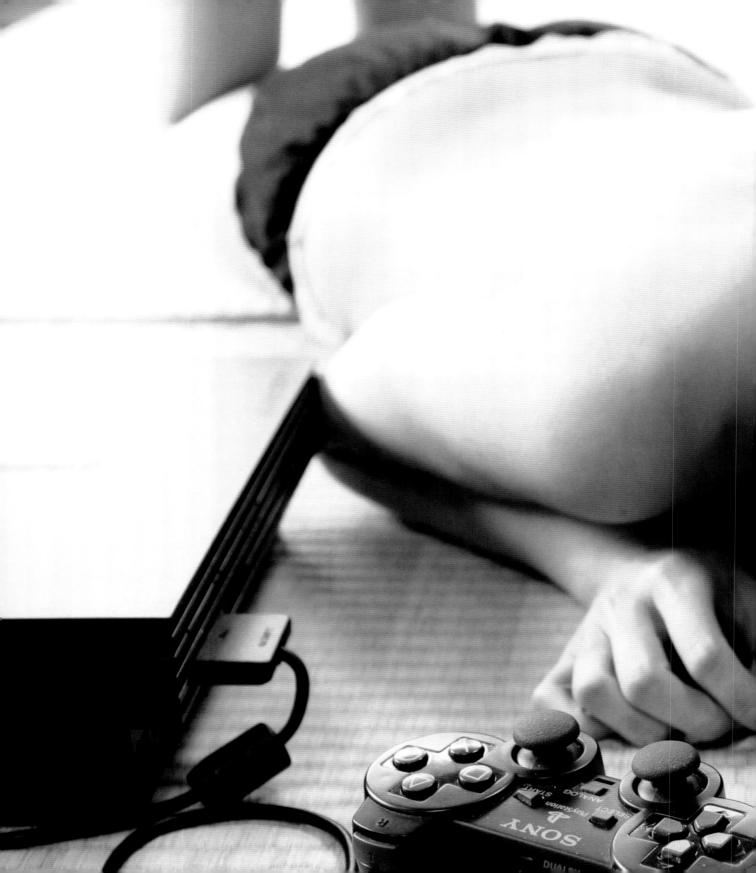

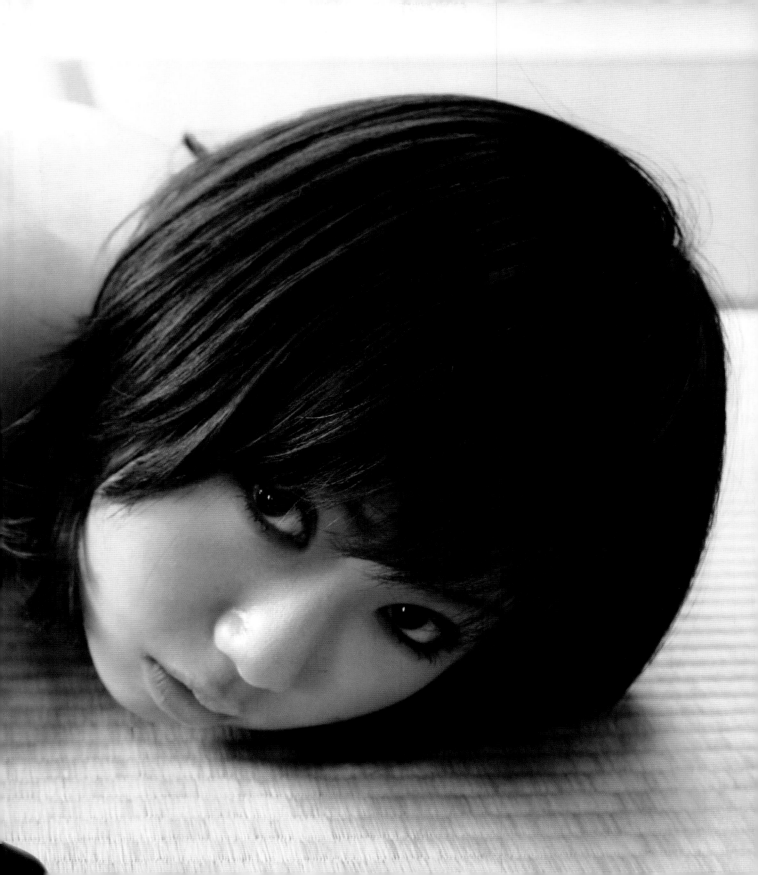

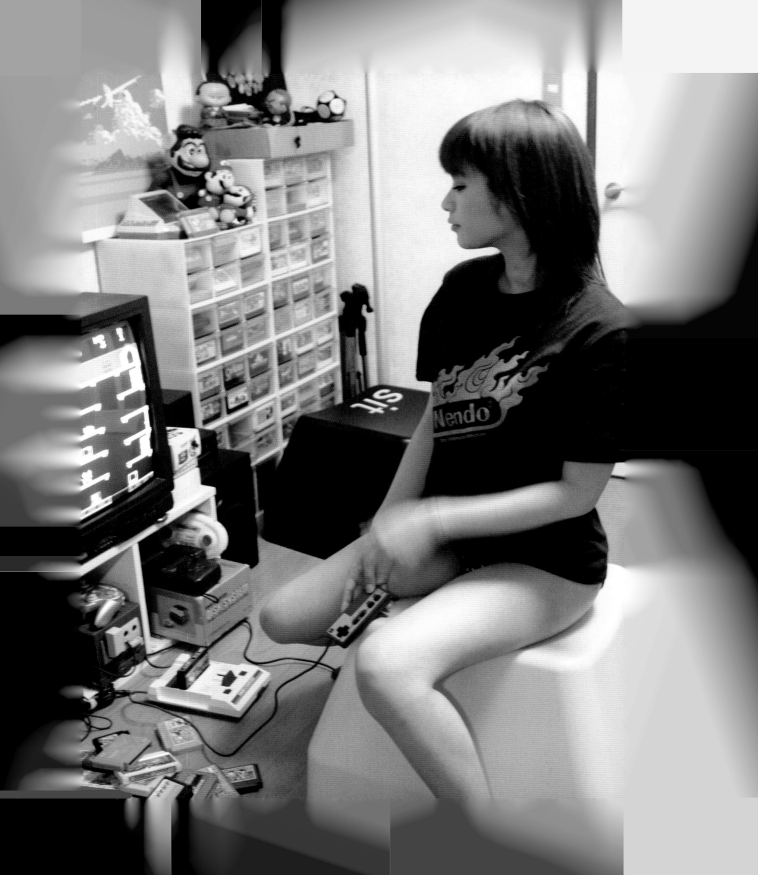

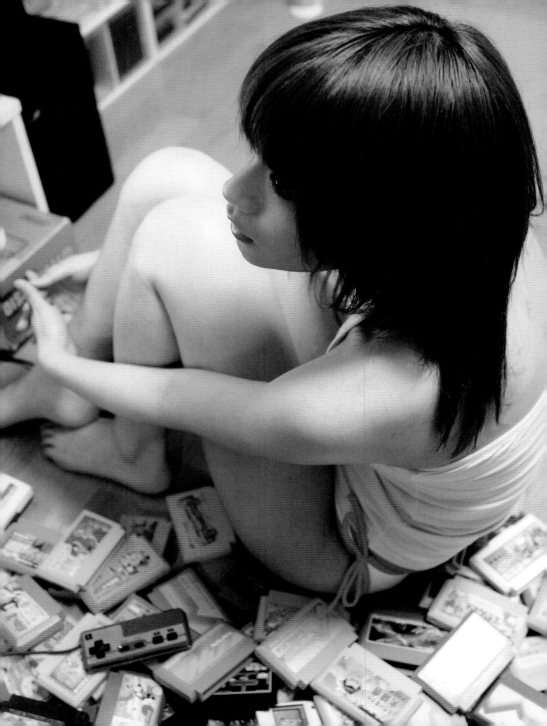

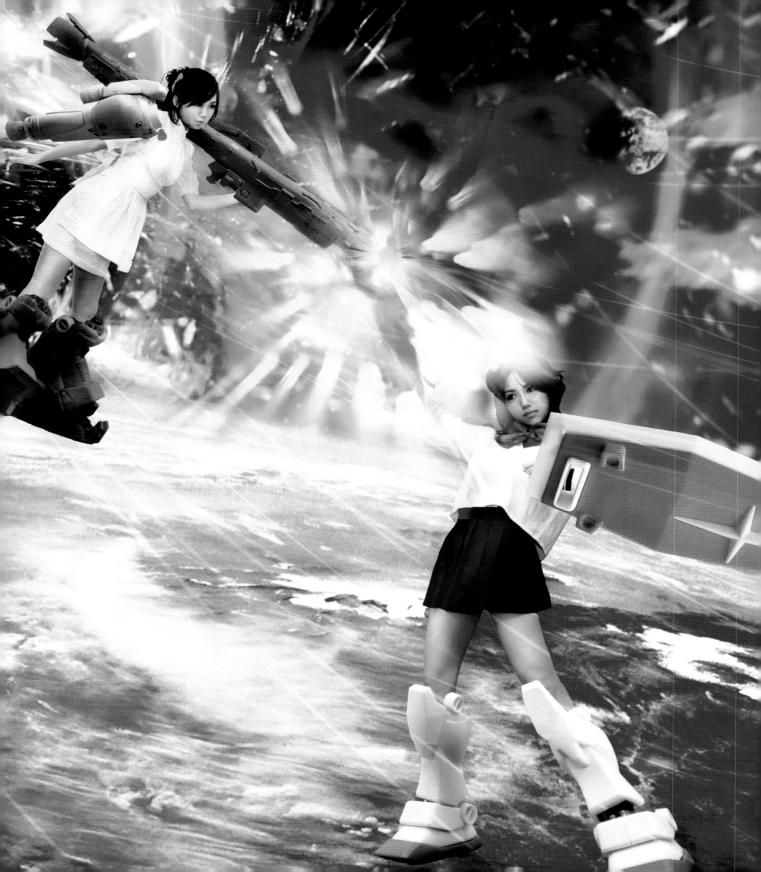

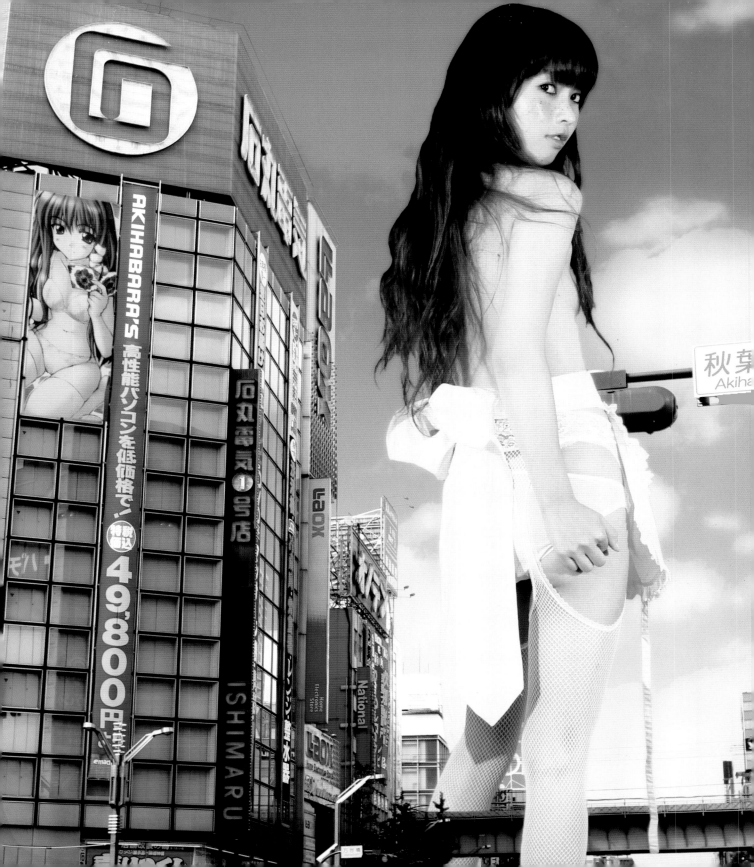

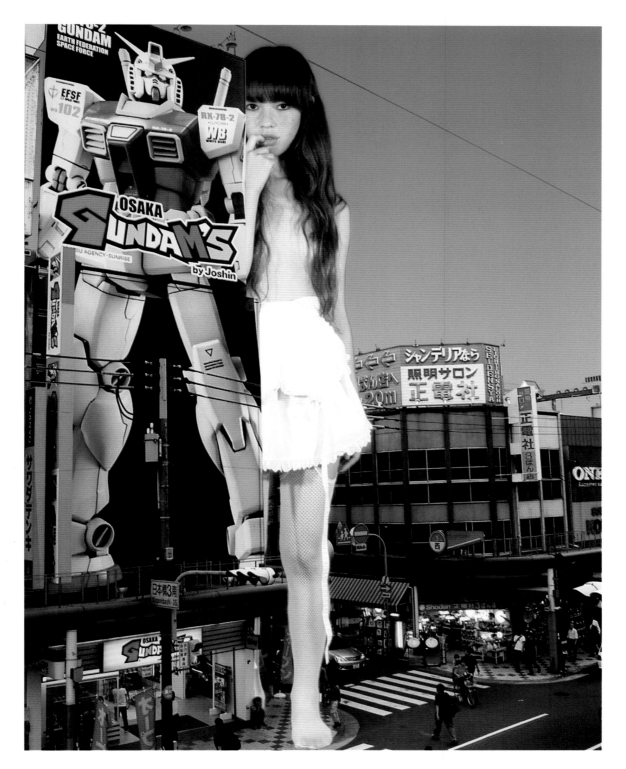

アヤ

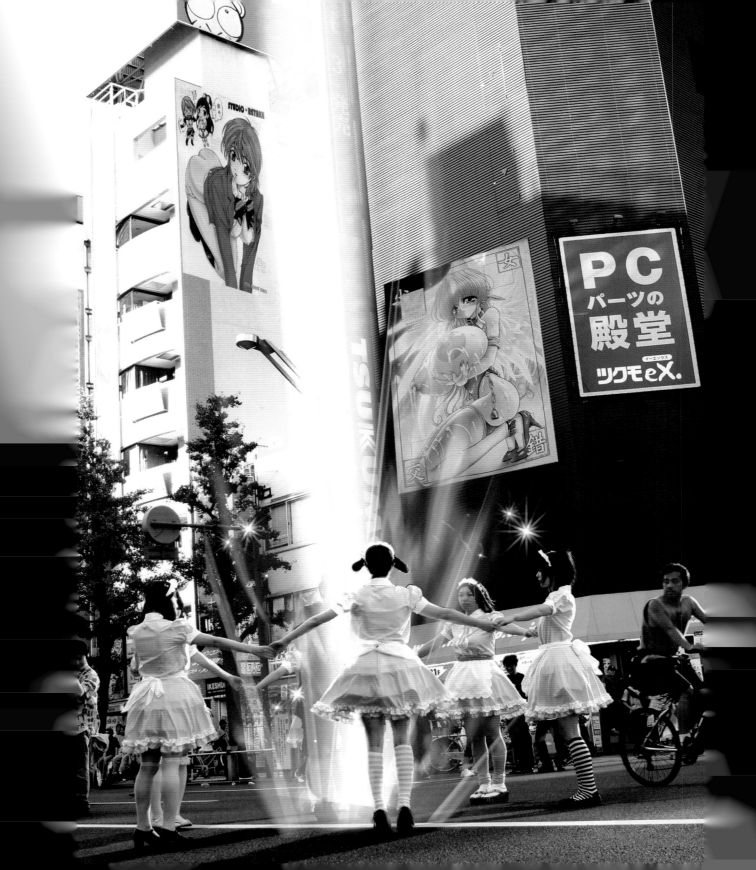

こゆは
ロープについて

縄。
(nawa)
日本語でのロープの意味。

ロープは さまざまな種類がありますが、
今回は この中で最も使われる「麻縄」を紹介します。
これは安全性が高いのと、視覚的にも雰囲気を
味わえるのでオススメです。
美少女ゲームで使用されるのも この麻縄、らしい。
「ロープは 彼女の安全性の為にも 知識と練習
が必要です！」

ロープはホームショップなどで買い、そのお店でカット
してもらいましょう。一般ショップの麻縄は
"なめし加工"が施されていないので使用すると
ケガのおそれがあります。

長さの比率は
こんな感じ

7m ←→ 12m

(160cm 45kg)　　(180cm 80kg)

ロープを手に入れたら次は「縛り」です。
実際は「縛る」というより「引っかける」という
表現がしっくりくる位弱い力で結んで
いきます。

ちょいと
楽なされ…

～「縛り」入門編～
STEP 1：「後手」
　　　　（うしろで）

（200年前の日本で実際に罪人を縛る時
などに使われていた縛り方です）

③ 更にもう一周手首に
巻きつけてから手首の所で
縛ります。

④ 図のように手首に
指2本分入る位の
余裕をもたせます。

① まず彼女の手首を
背中側の腰のあたりで
交差させます。

縄を一本取って二つ折りに
します。（省略）
その折り目を手首の背中側
を下から上に約30cmほど
通します。

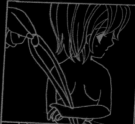

② 縄を交差した手首を
一周させます。

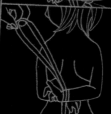

⑤ 結び目を下に
引っぱって締め
ます。

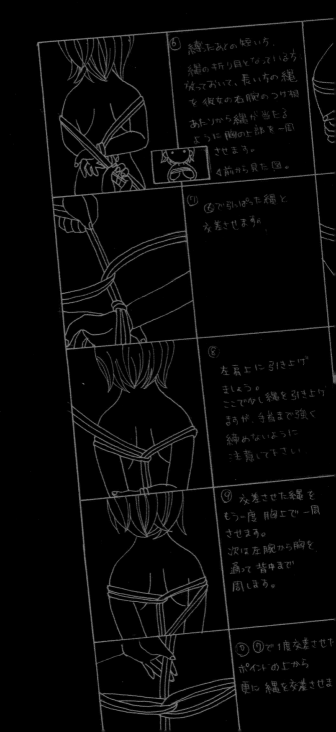

⑥ 縛ったあとの短い方.
縄の折り目となっている方は
放っておいて、長い方の縄
を 彼女の右腕のつけ根
あたりから縄が当るよ
うに胸の上部を一周
させます。
◁前から見た図。

⑦ ⑥で引っぱった縄と
交差させます。

⑧
左肩上に引き上げ
ましょう。
ここで少し縄を引き上げ
ますが、手首まで強く
締めないように
注意して下さい。

⑨ 交差させた縄を
もう一度 胸上で一周
させます。
次は左腕から胸を
通って 背中まで
周します。

⑩ ⑦で1度交差させた
ポイントの上から
更に 縄を交差させま

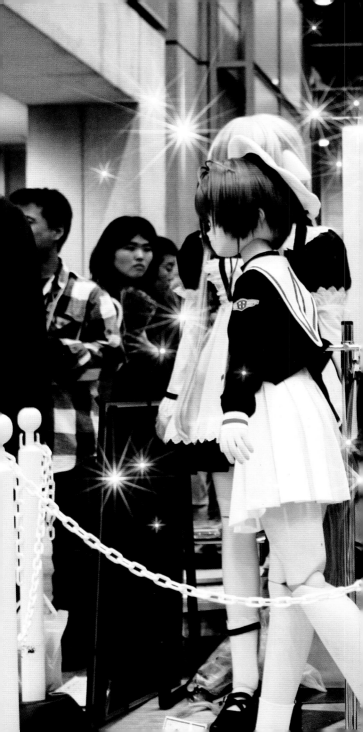

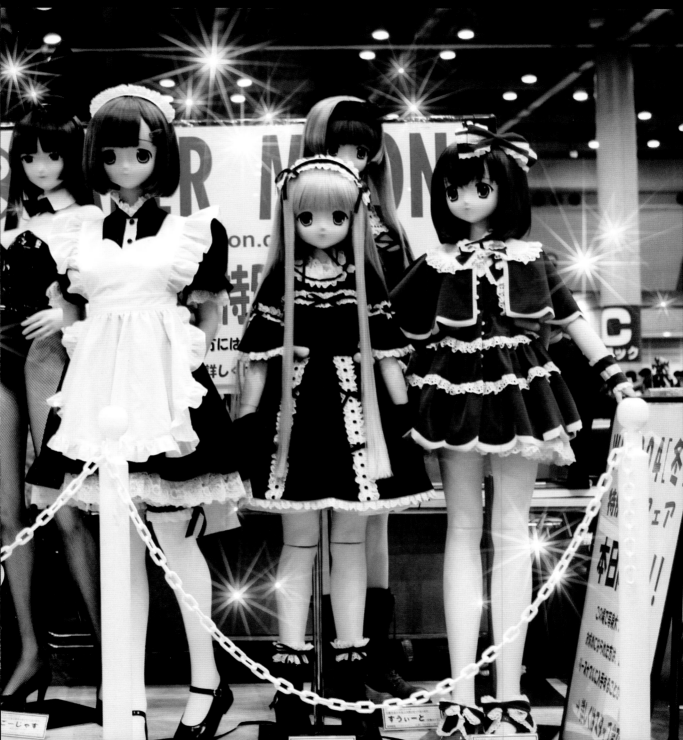

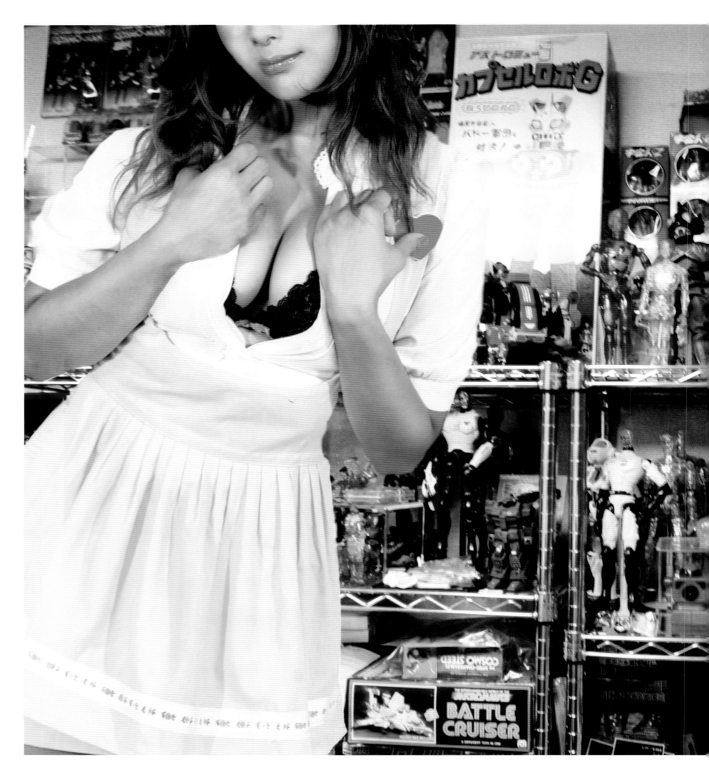

ウオ

GO AKIBA GO

GIRLS GOT A BRAN

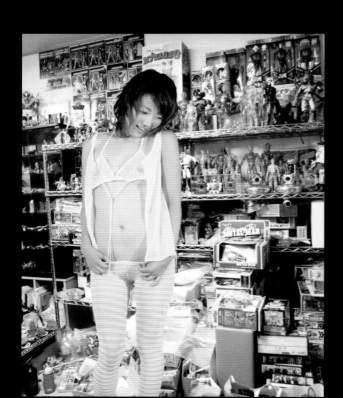
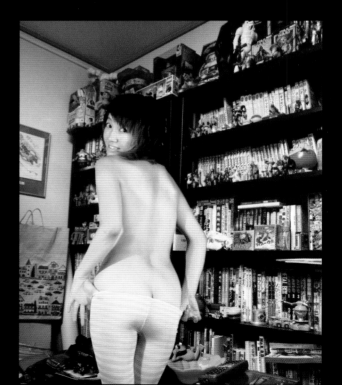

NEW TOY

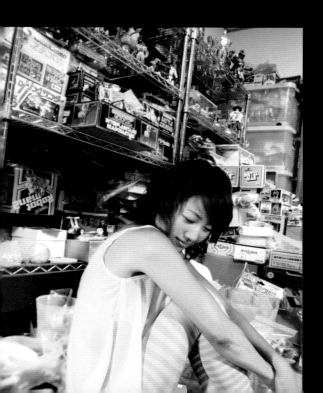

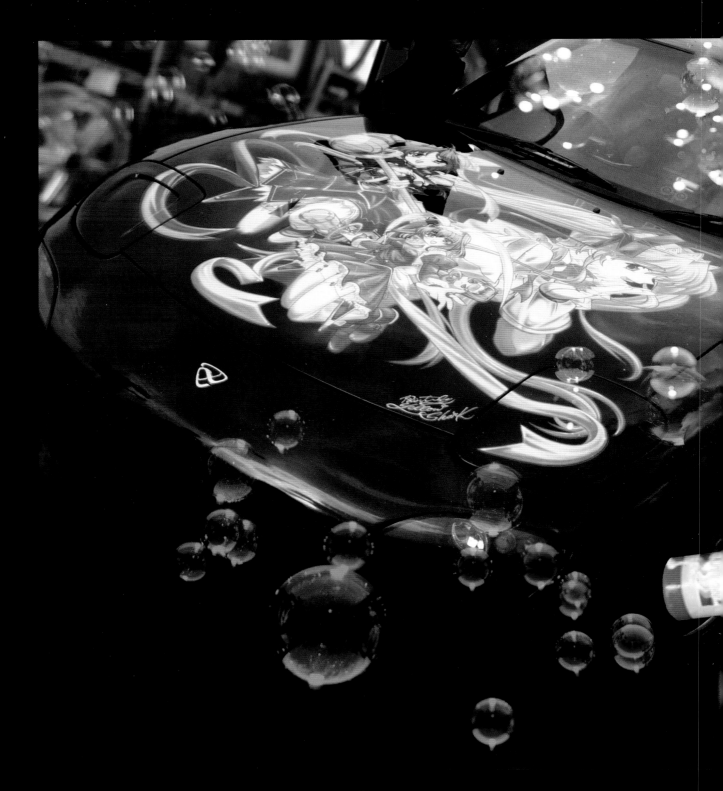

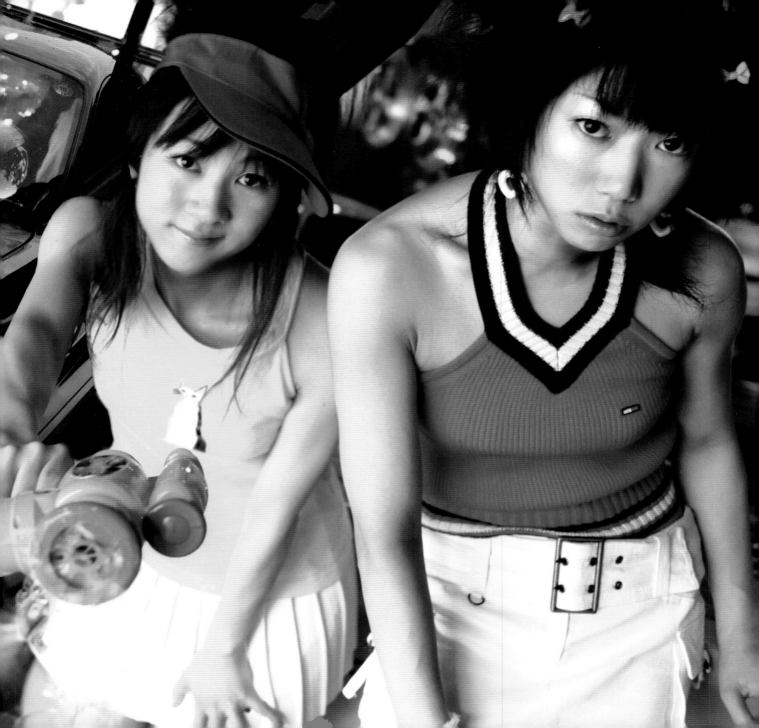

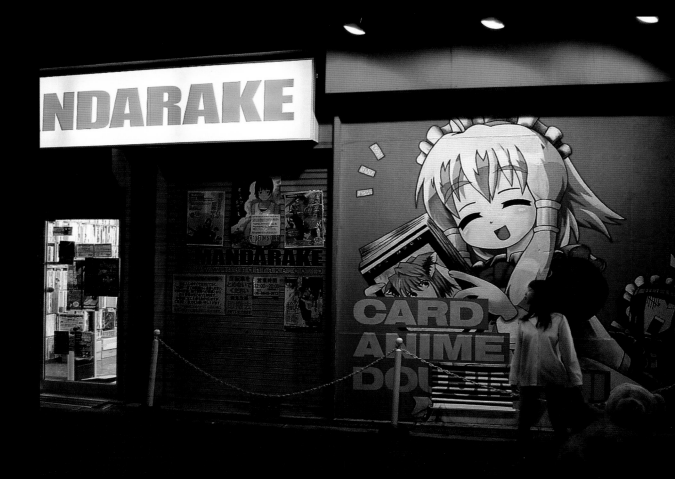

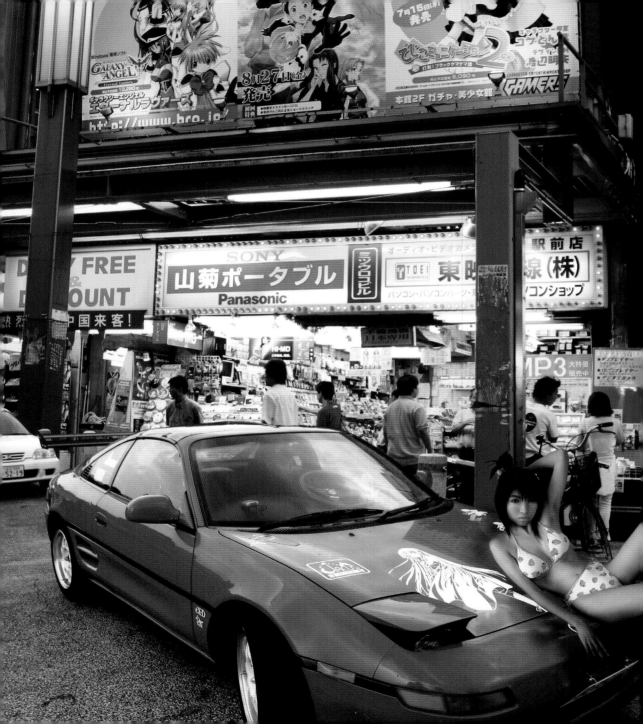

エオ

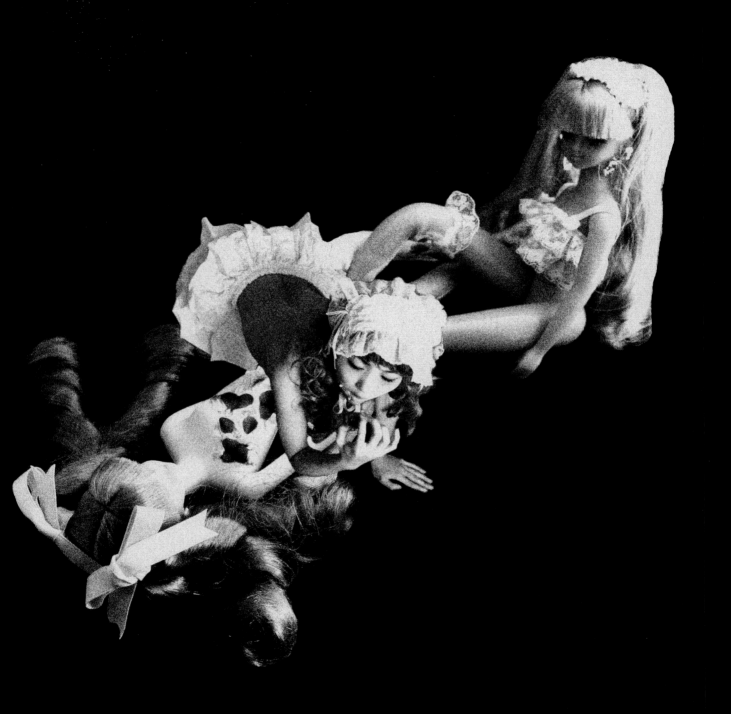

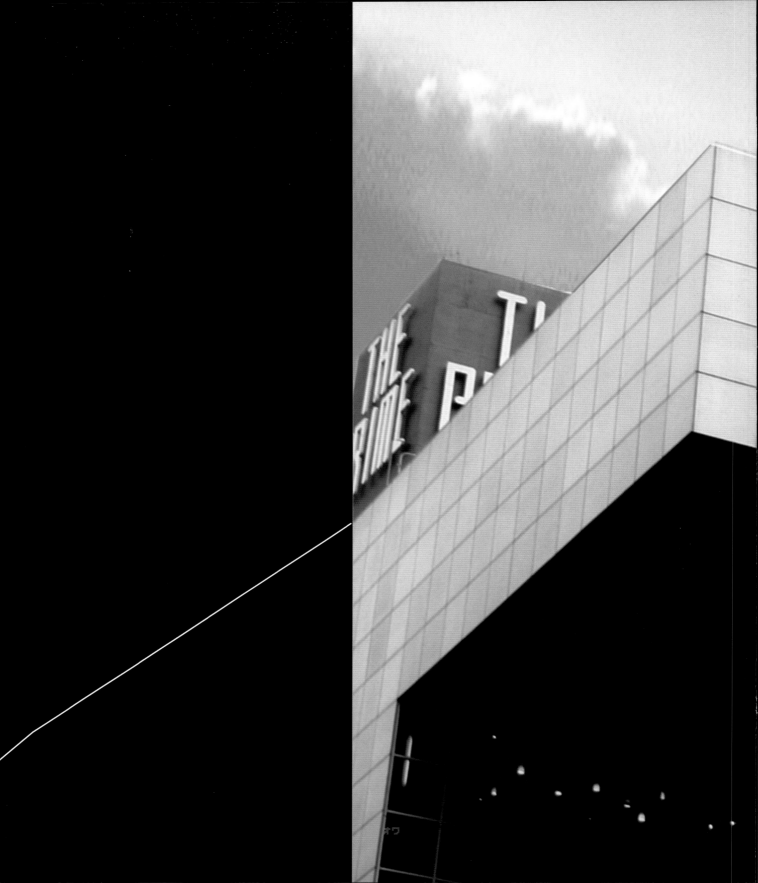

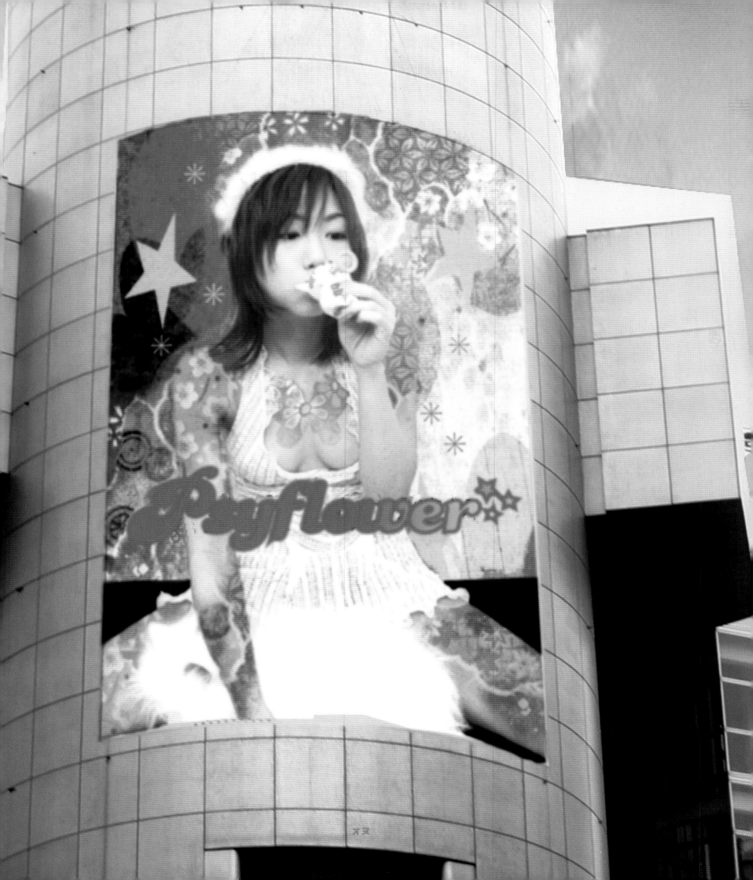

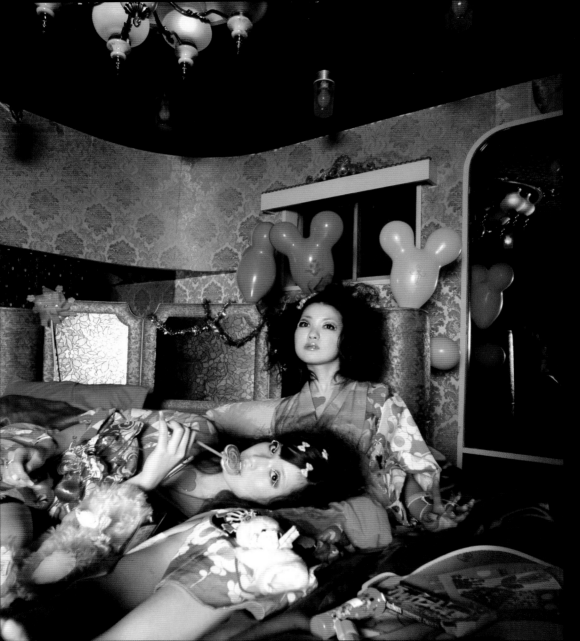

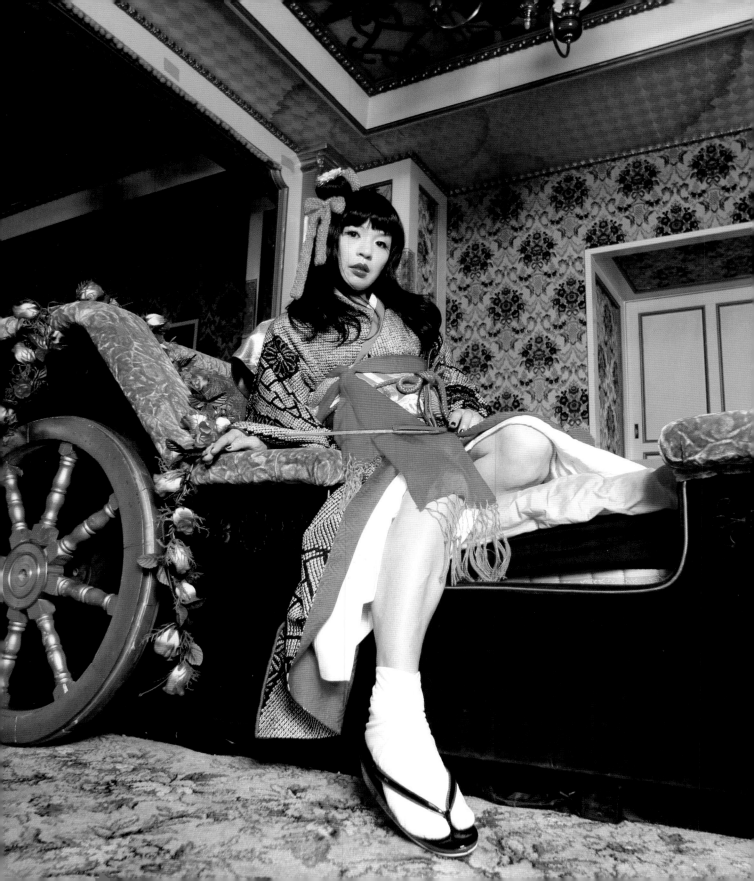

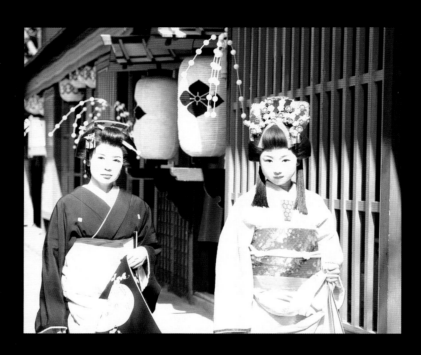

ばしょいどう
あたりを　みろ
ひとに　きけ
ひと　しらべろ
ひとに　みせろ
ひきとらせろ

けいしゃ「きくやっこ　ともうします。
　　　よろしくね♥
ボス「？

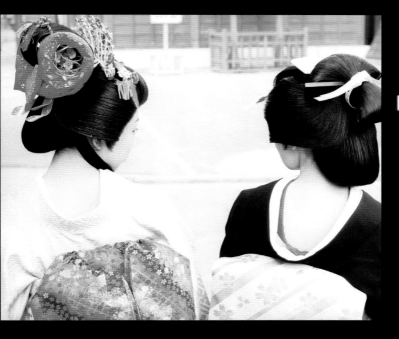

ばしょいどう
あたりを み
▶ひとに きけ
ひと しらべ
ひとに みせ
ひきとらせろ

けいしゃ「なに きょろきょろ なさってんの？
　けいしゃ あそびは はじめて？
ボス「？

オエ

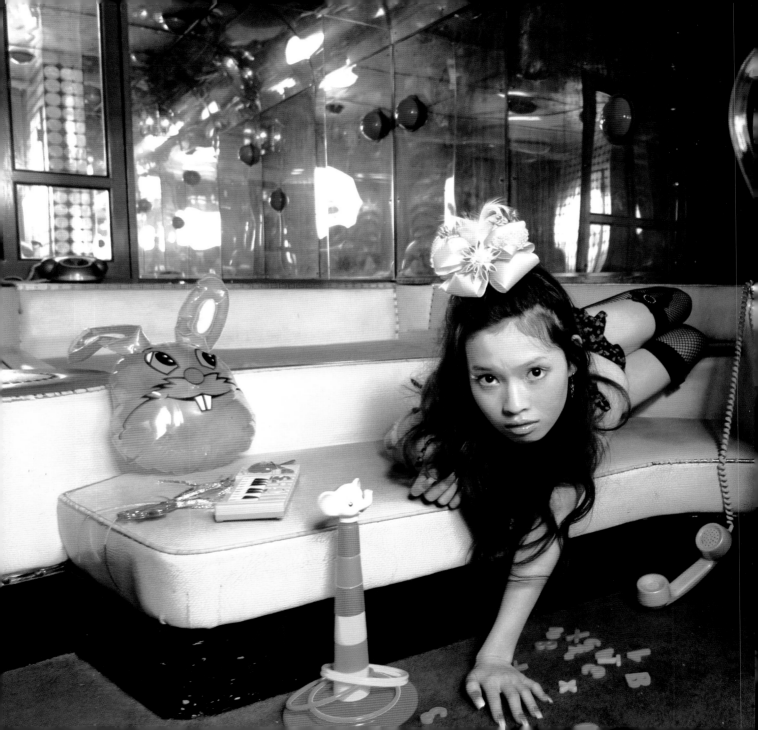

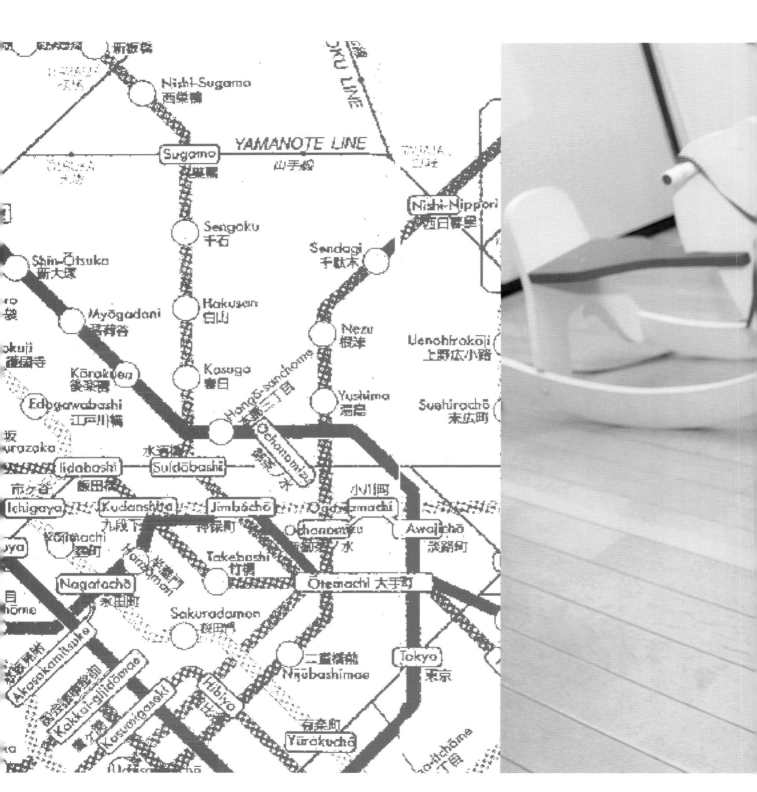

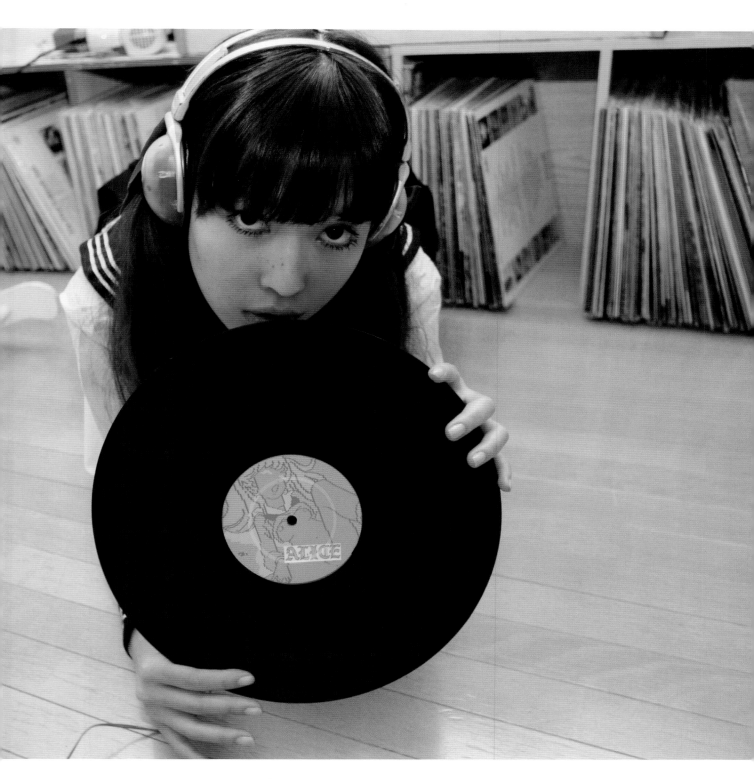

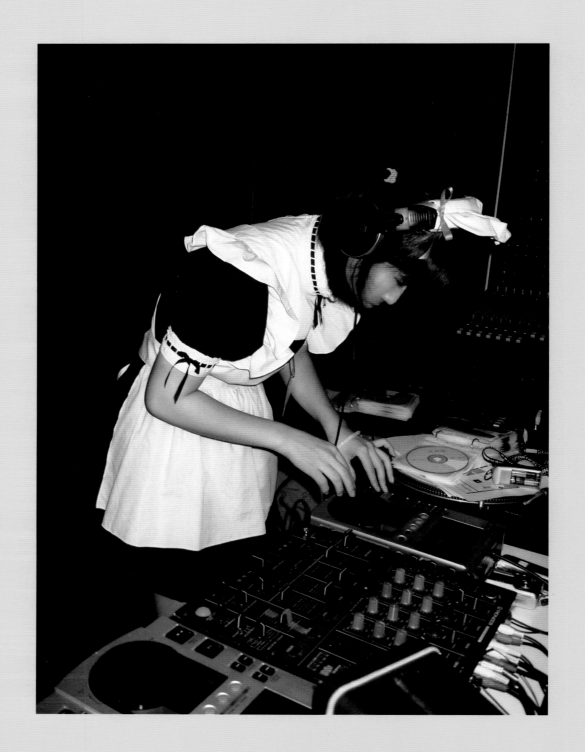

ワ

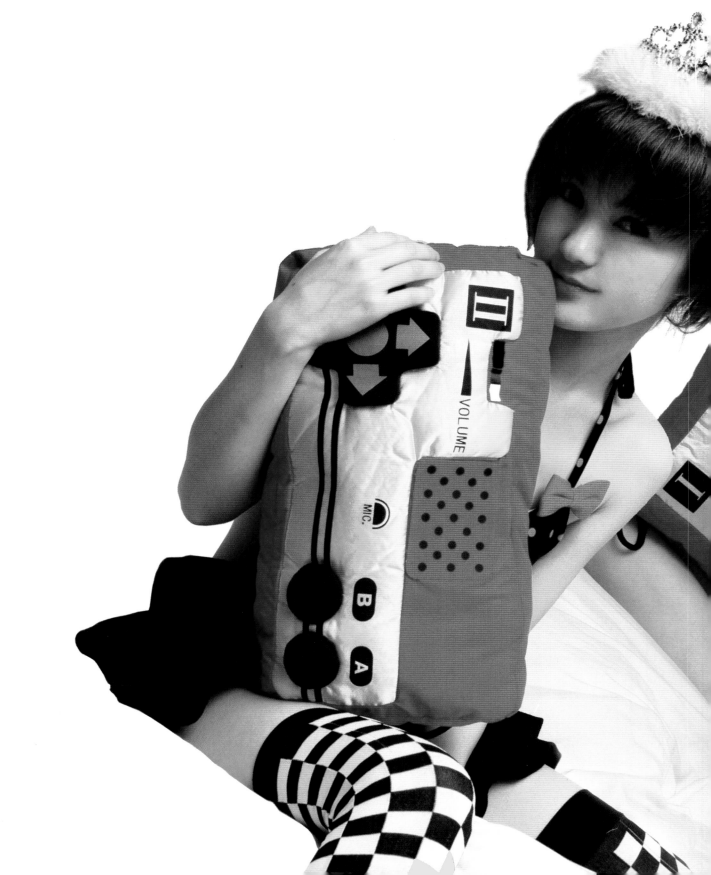

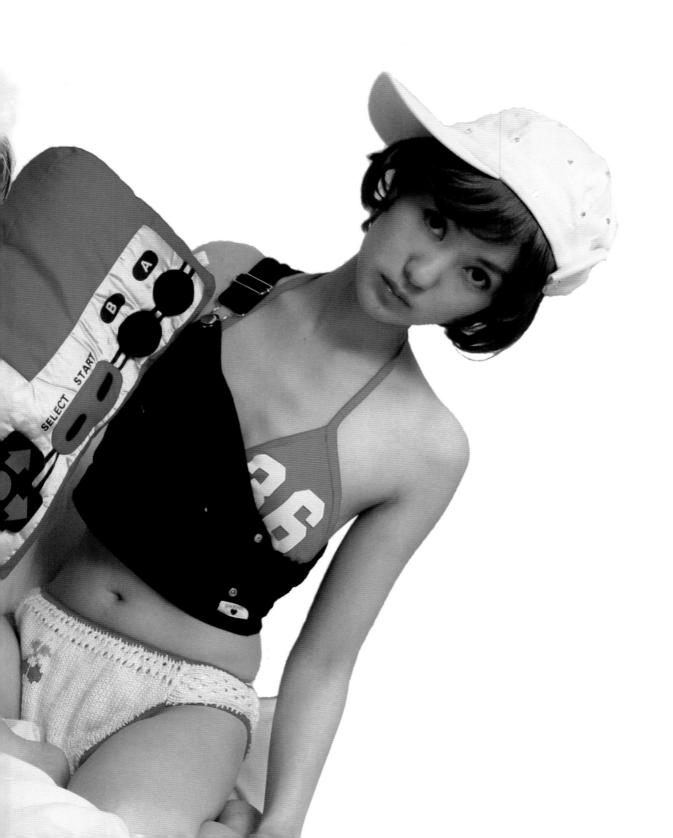

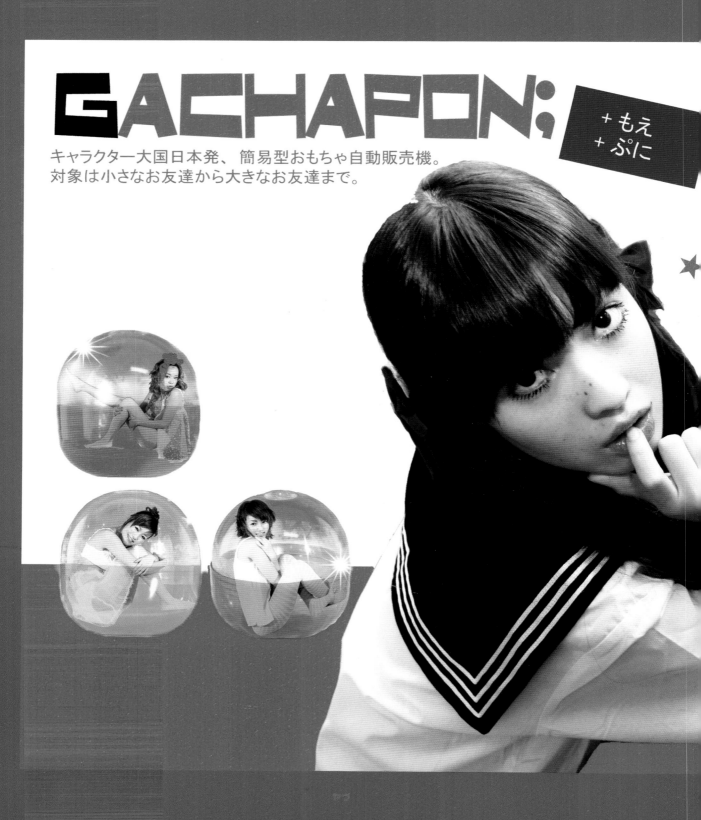

GACHAPON;

+もえ
+ぷに

キャラクター大国日本発、簡易型おもちゃ自動販売機。
対象は小さなお友達から大きなお友達まで。

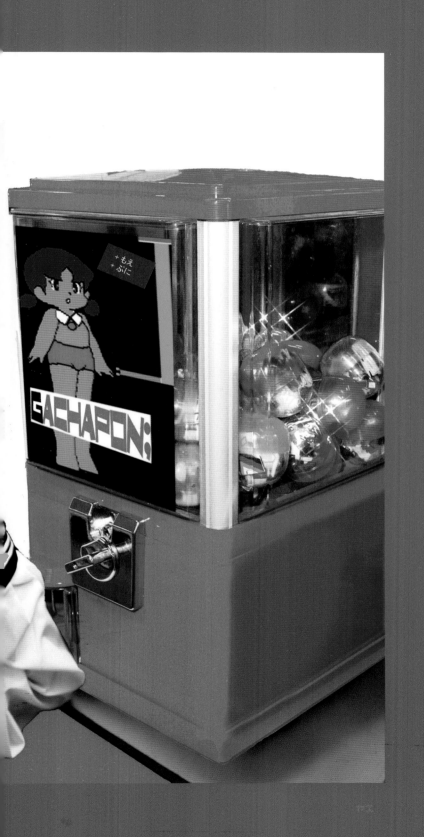

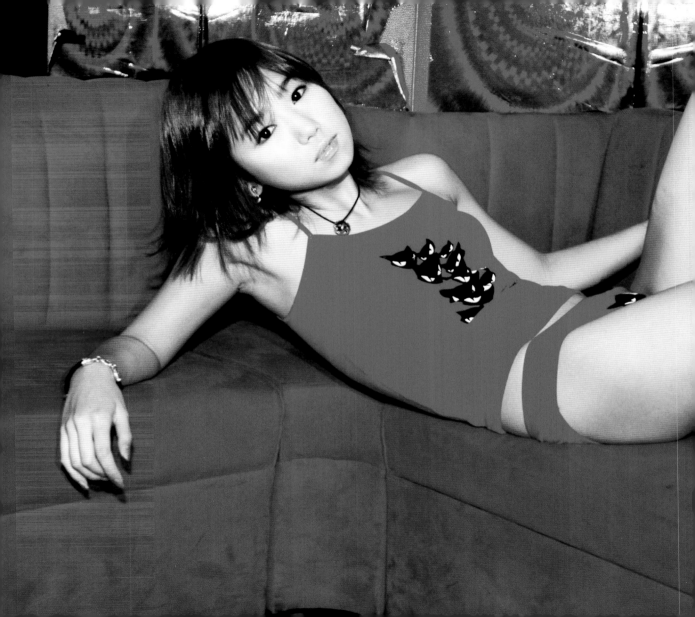

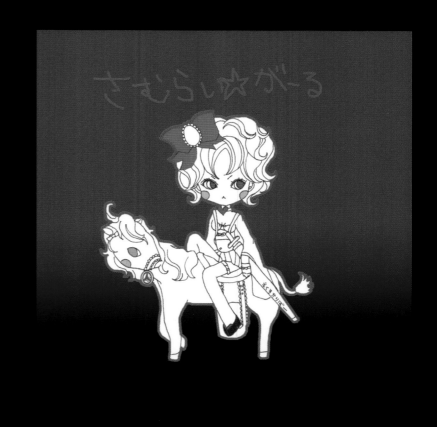

さむらい☆がーる

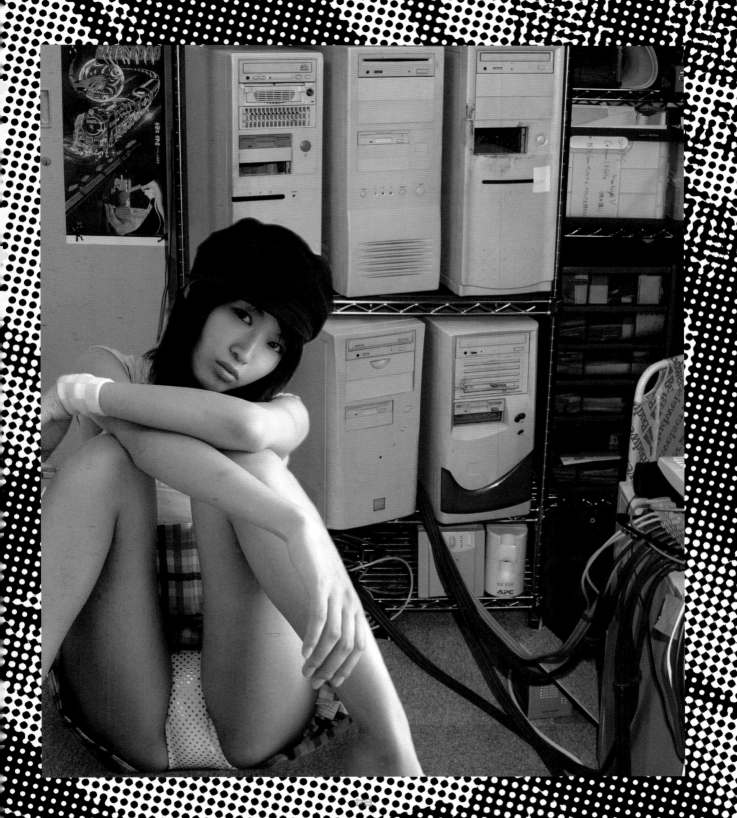

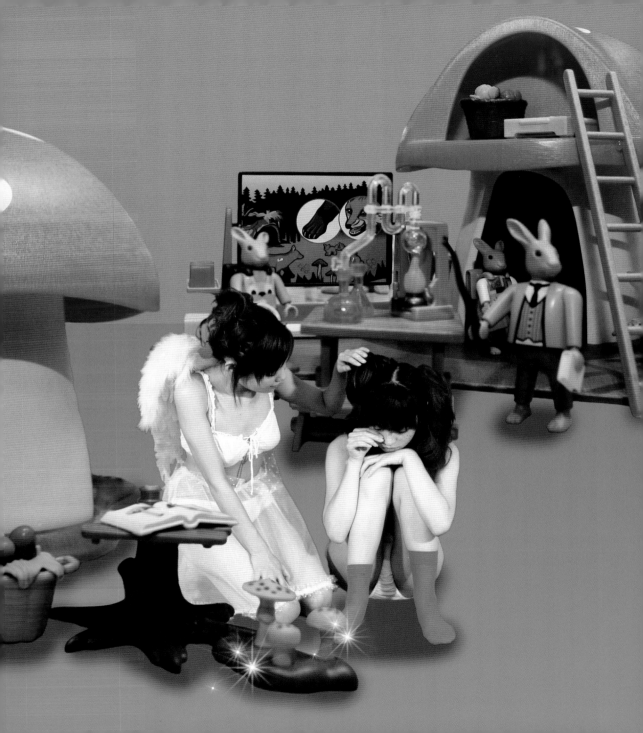

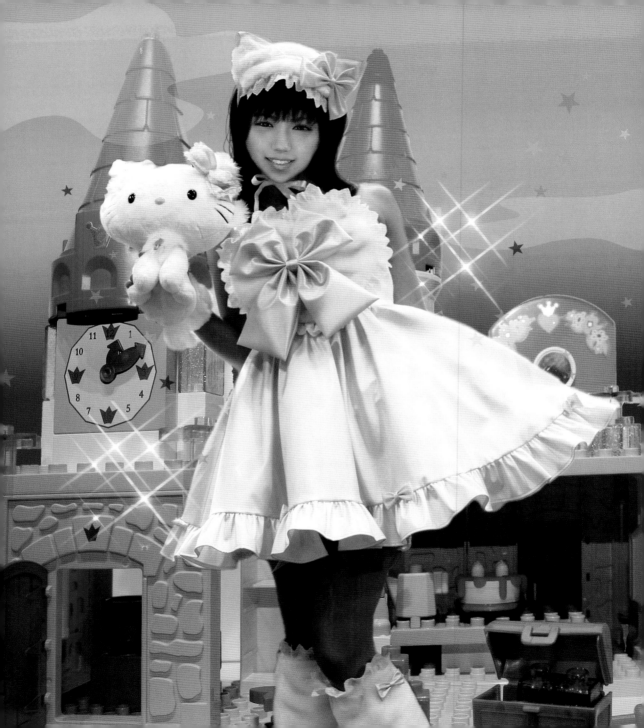

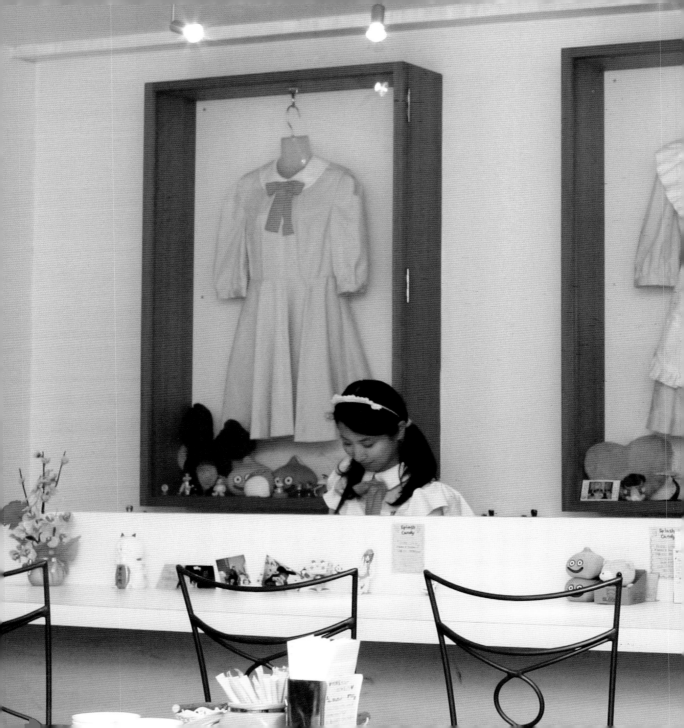

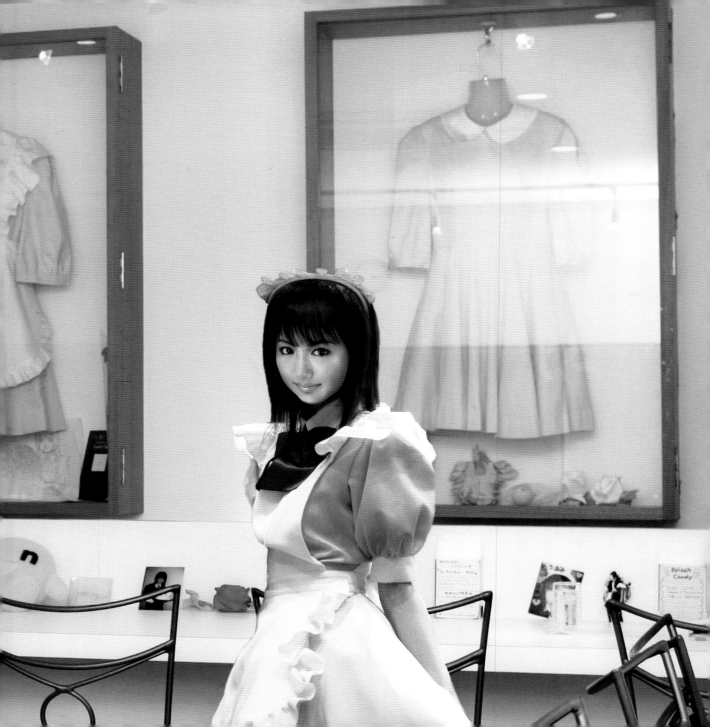

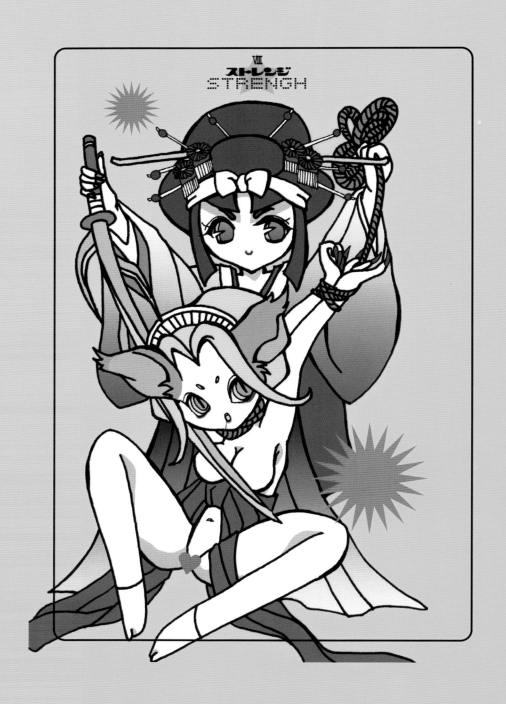

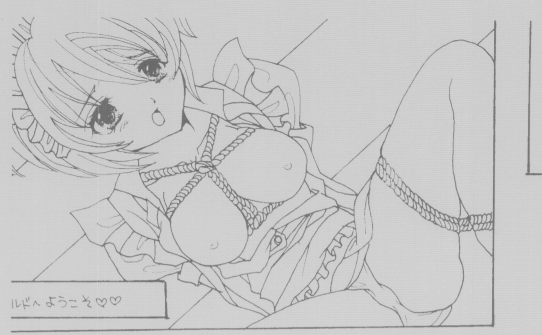

ルドへ ようこそ ♡♡

♪Julieです。
エゲーム界では
きざしが見えますが
がお暮らしで
ーか。

という訳で今回の
テーマは ズバリ
✧SM✧

際のSMって
ぎるイメージが
だよねェ。

特に
コレとか コレ
とか →

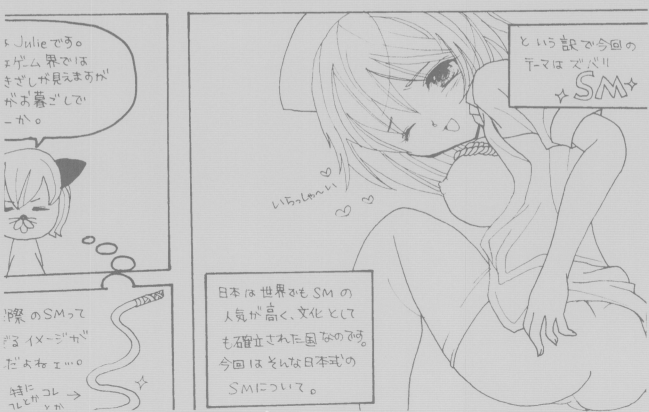

いらっしゃ～い ♡
♡

日本は世界でも SM の
人気が高く、文化 と して
も確立された国 なのです。
今回はそんな日本式の
SMについて。

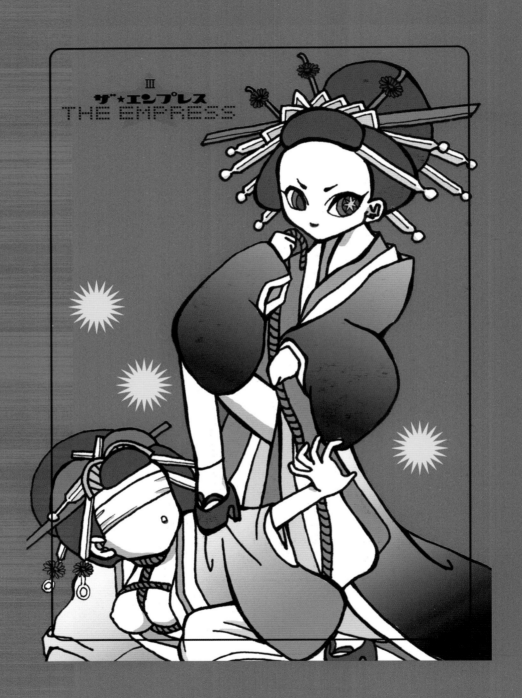

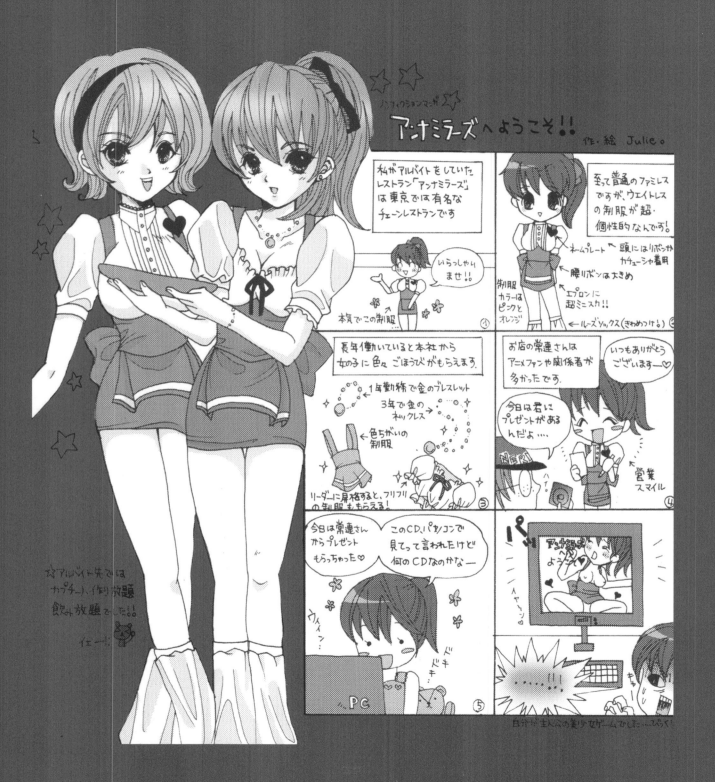

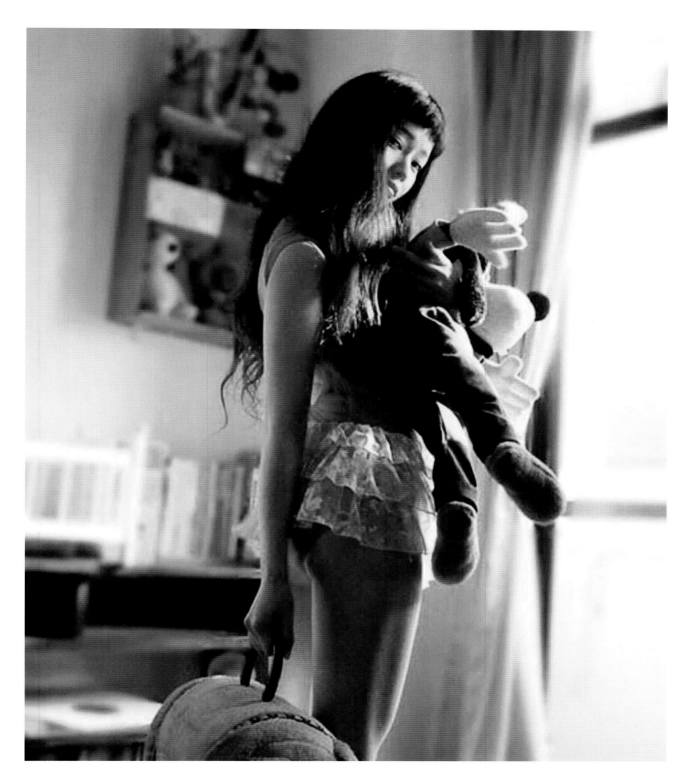

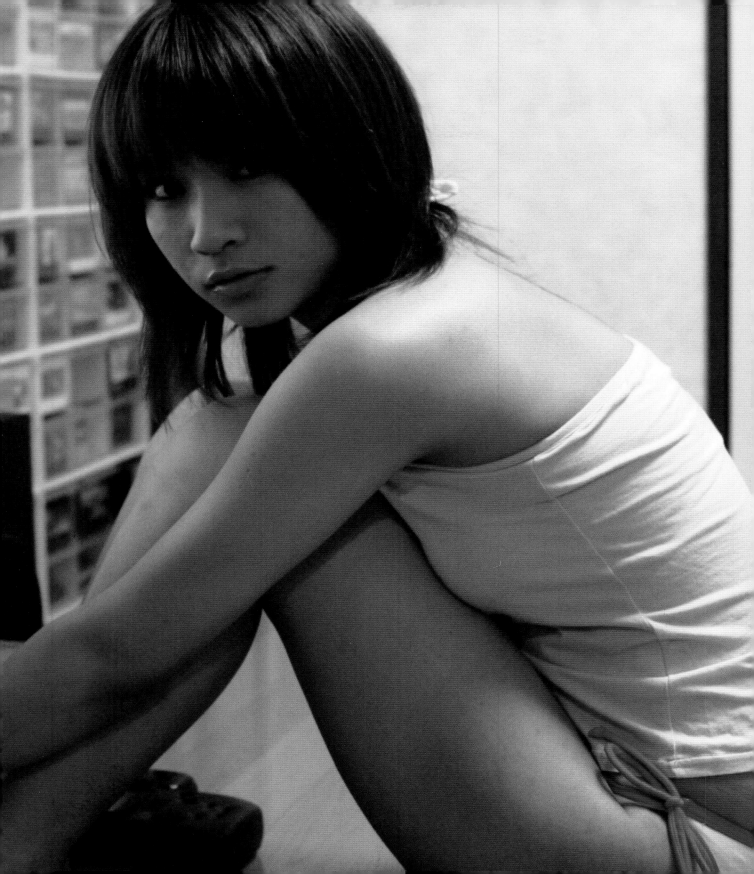

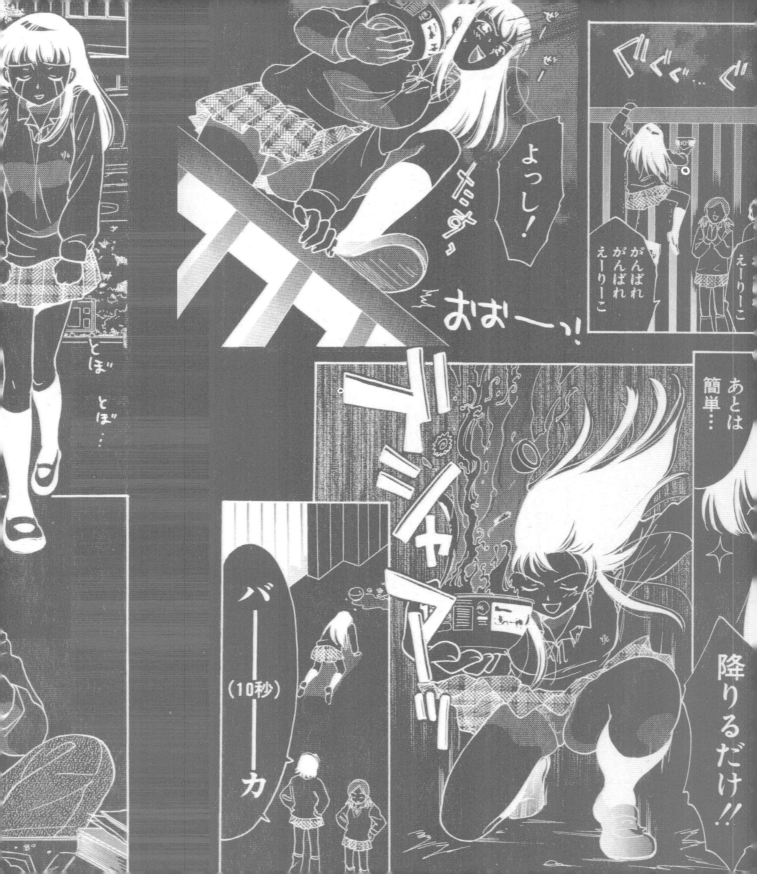

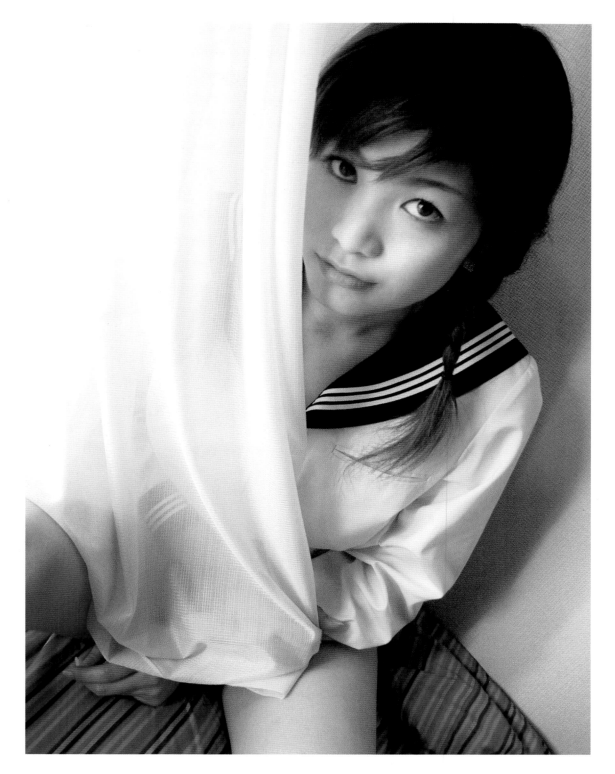

もっく

送られたが、3

各1点の優秀賞を

佳作・入選作品

れた。また、1・

部門では82歳の

まさおさんに特別

られた。入賞作品

の時

セン

年1月3日〜2月

表彰式は1月14

り時半から、川崎

崎市民ミュージ

行われる。

審査委員

西村宗

コミックイラ

「フラミンゴが

▶ストーリーマン

「ニトロマン」

れはできるものなので

どんどん作品を描いても

らいたい。

きなユメを持つ君へ」

【優秀賞】

阿部加奈子（日本アニメ・マ

ンガ専門学校）「フラミンゴが

た！！」（横浜市）△

かずの踏切」他3

黒川幹雄「よく来

北條弘2点（東京都

◇コミックイラスト部門

【佳作】

亜優美

（同）△渡

葉県山武郡）△かみ

今関文男「相次ぐ事

【入選】

「まったりコロシア

浦安市）△鵜飼芳生

市）

神谷知子4点（岐

【優秀賞】

ユメを持つ君へ」

【グランプリ】

該当作品なし

◇ストーリーマンガ部門

【入選者名簿】

荻野健（あいち造形デザイン

専門学校）△

小柳幸絵（日本アニメ・マン

ガ専門学校）△渡辺悠（同）△

渡辺美里（同）△高井美緒子

ューマンアカデミー東京校）△

県春日部市）△黒阿木直人（ヒ

姫（埼玉

話の森」

くる

プロ

育て

ちょ

に持

佐藤忠史「いって

臣の椅子」（三重

（京都府宇治市）△

県佐世保市）△千葉

い」（札幌市）△金

日はしてないよ

shino.（北

△小林拓弥「母と

堺市）△鵜飼芳生

ューマンアカデミ

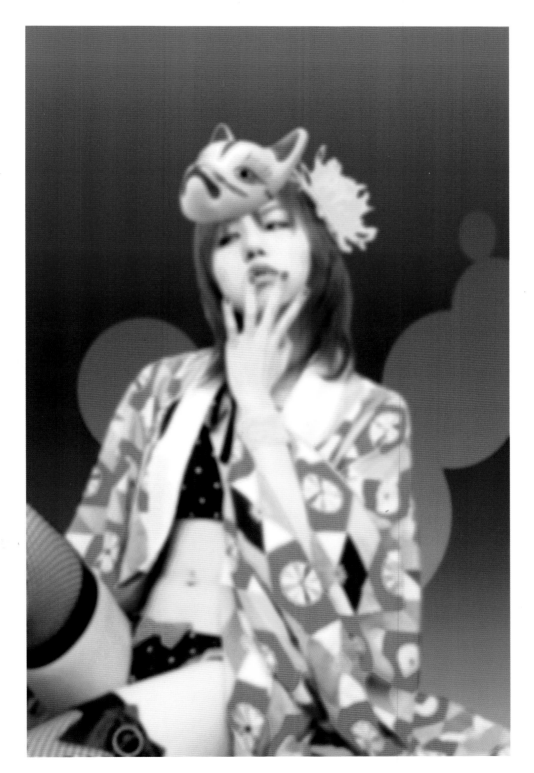